## ALSO BY SY MONTGOMERY

*Of Time and Turtles*
*The Hawk's Way*
*The Hummingbird's Gift*
*How to Be a Good Creature*
*The Soul of an Octopus*
*Birdology*
*The Good Good Pig*
*Search for the Golden Moon Bear*
*Journey of the Pink Dolphins*
*Spell of the Tiger*
*Walking With the Great Apes*
*The Wild Out Your Window*
*The Curious Naturalist*

## FOR YOUNG READERS

*The Book of Turtles*
*The Seagull and the Sea Captain*
*Becoming a Good Creature*
*Condor Comeback*
*Inky's Amazing Escape*
*The Octopus Scientists*
*The Hyena Scientist*
*The Magnificent Migration*
*The Great White Shark Scientist*
*Chasing Cheetahs*
*The Tapir Scientist*
*Amazon Adventure*
*Temple Grandin*
*Kakapo Rescue*
*The Tarantula Scientist*
*Quest for the Tree Kangaroo*
*Saving the Ghost of the Mountain*
*The Snake Scientist*
*The Man-Eating Tigers of Sundarbans*
*Encantado*
*Snowball the Dancing Cockatoo*
*Search for the Golden Moon Bear*

*In memory of Wilson Menashi*

# SECRETS OF THE
# OCTOPUS

## SY MONTGOMERY

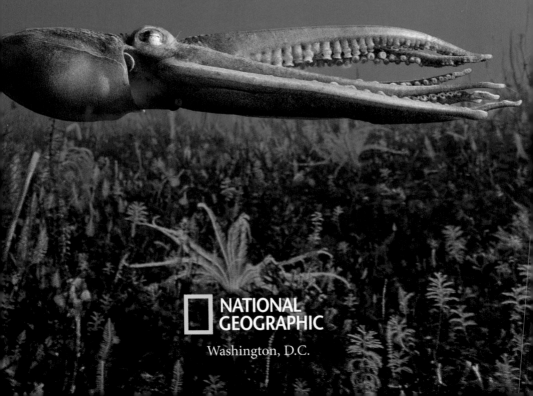

**NATIONAL GEOGRAPHIC**

Washington, D.C.

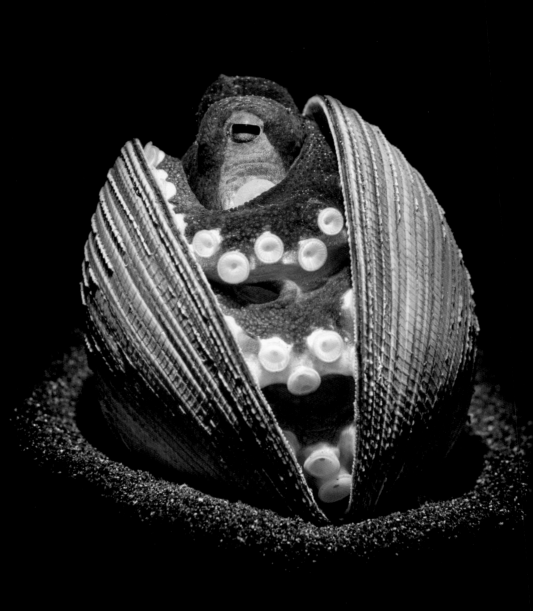

# Contents

A veined, or coconut, octopus (*Amphioctopus marginatus*) shelters inside a clam shell.

PAGES 2-3: An octopus, tinged blue by hemocyanin, a pigment in its blood, jets through the subfreezing temperatures of the Antarctic Sea.

PAGES 6-7: An octopus basks in the springtime waters of the Mayotte Archipelago, between the coast of Mozambique and the island of Madagascar.

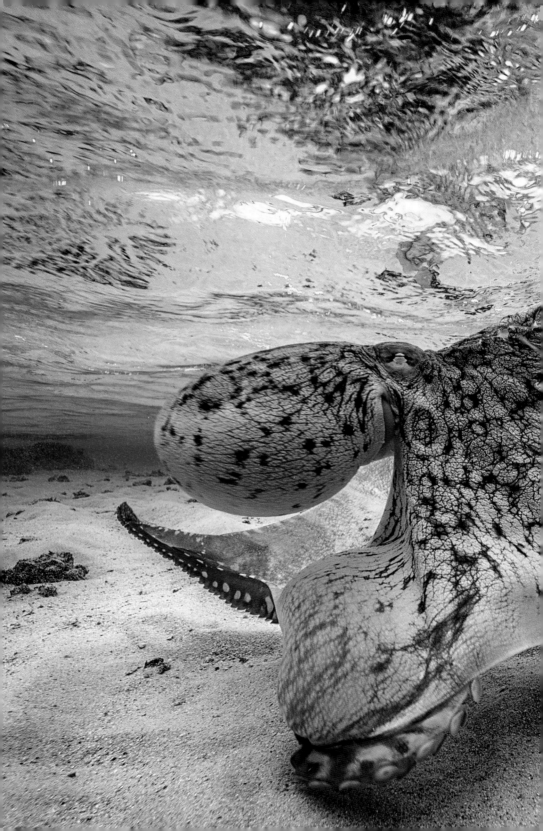

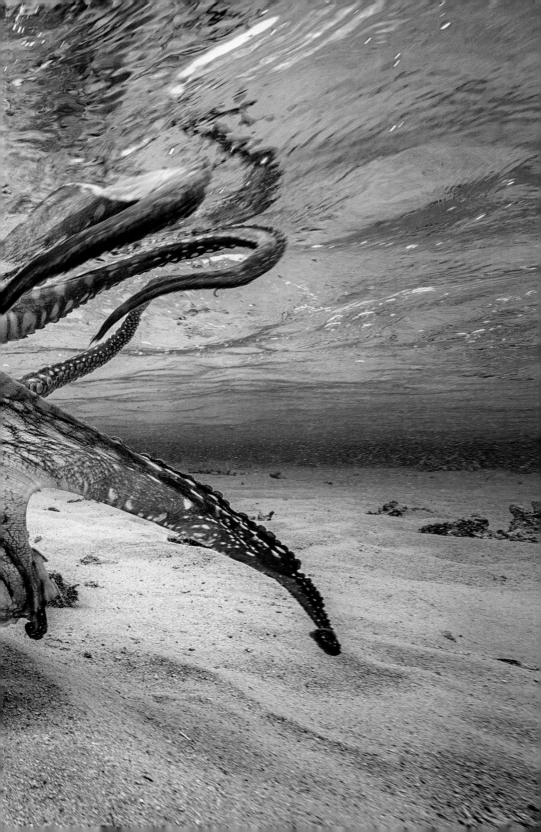

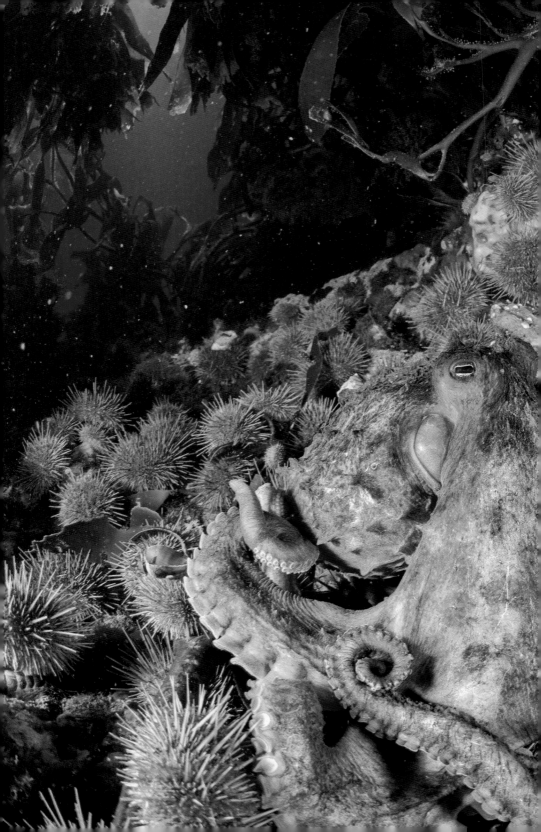

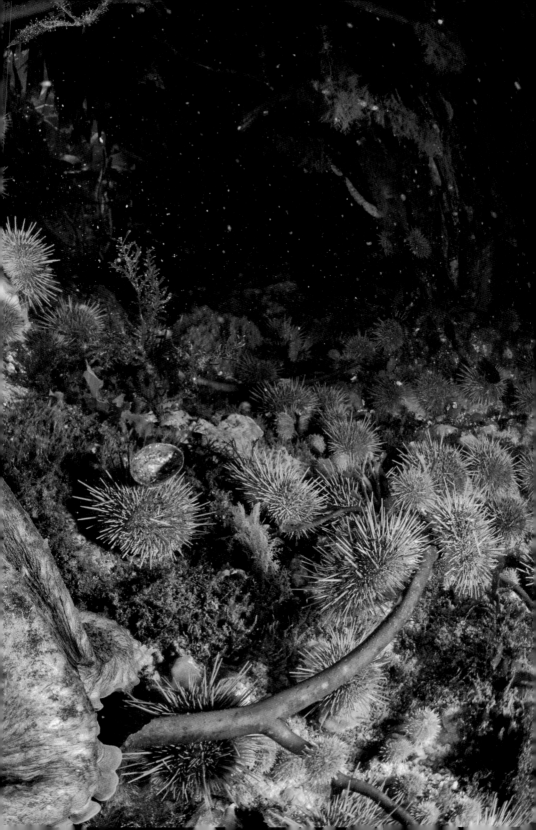

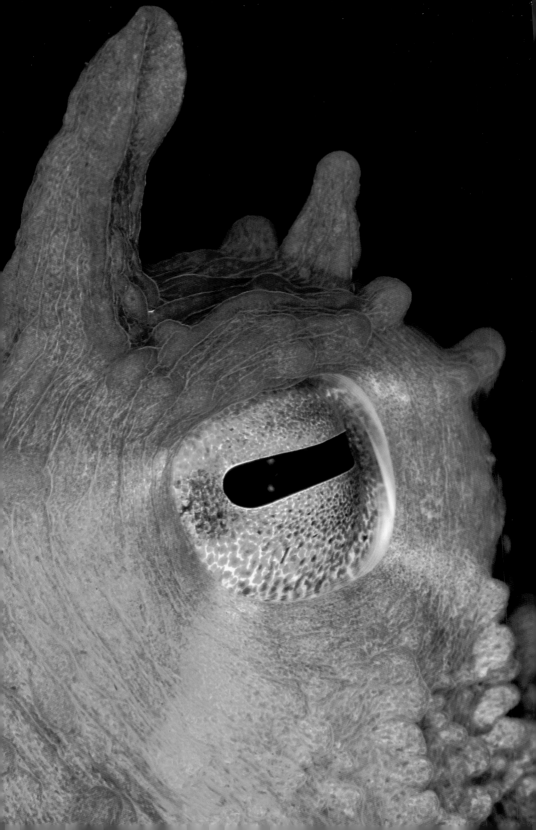

# FOREWORD
## ALEX SCHNELL, PH.D.

While the ocean had always captivated my mind, it was my first encounter with an octopus that captured my heart and later inspired me to become a marine biologist.

That day, the sky was clear and the ocean as smooth as glass. I wanted to explore the contents of a rock pool but was struggling to see past my own reflection. Undeterred, my five-year-old self blindly felt around for critters—sea stars, hermit crabs, periwinkles—until my hand touched something soft and slippery. A sea slug perhaps? The sensation was odd. The obscured creature moved over my skin with clear interest. Tiny suction cups gently rolled across the palm of my hand. It felt like a caress. In hindsight, this was our first contact: my *E.T.* moment, the initial meeting of two curious beings from different worlds.

I slowly lifted my hand, bringing the arm of the critter into view. Lying outstretched in my palm was a small, boneless limb, reddish in color and lined with hundreds of suckers. Hungry to learn more, I attempted to see through the water's reflection by squinting and refocusing my eyes. Like a

The eye of a giant Pacific octopus (*Enteroctopus dofleini*) displays its horizontal pupil.

PREVIOUS PAGES: A southern red octopus (*Enteroctopus megalocyathus*) rests on a bed of sea urchins at Isla de los Estados, Argentina.

hidden image embedded in a stereogram painting, a peculiar form started to take shape. The arm in my hand seemed to be attached to what looked like a water balloon the size of an orange. I could not make sense of the figure yet, so my eyes searched for something familiar. I settled on two remarkably large eyes atop the balloon. Peeking up at me from a peculiar and exquisite face were the strange rectangular pupils of an octopus.

She extended two more arms to explore my hand, and in that instant, her skin magically transformed in both color and texture. While the brilliance of this transformation delighted my youthful imagination, I have since learned that it also carried a much deeper meaning. Such changes in octopus skin resemble emotional expression, the way a human might frown, smile, or blush. Was she amused, confused, or surprised? Or was she feeling entirely different emotions? (There's compelling evidence that octopuses *do* feel in this manner.)

That day, the ocean revealed to me a secret: One of her most bizarre and mysterious inhabitants was also tenderly curious. Here was a wild octopus, naturally solitary, a fierce and intelligent predator, and yet inquisitive enough to willingly interact with an alien creature (me).

SINCE THAT FIRST EXCHANGE, I've been fortunate to have numerous encounters with different octopuses. Each meeting is memorable, wonderfully weird, and surprisingly elusive. I'm often left with the profound feeling that I've encountered another intelligent mind, sparking more questions than answers.

I'm not alone. People who have met an octopus often describe the encounter in a similar manner: intimate yet strange, driving a thirst to uncover more of the octopus's secrets.

*Secrets of the Octopus* provides a window into the lives of these mysterious creatures. In this captivating book, Sy Montgomery, an American naturalist and cephalopod enthusiast, divulges the remarkable behaviors and individual quirks of octopuses.

The story begins with a visual journey to learn about the magic of octopus skin. Octopuses are sophisticated shape-shifters who can instantly transform themselves to resemble a spiky chunk of coral, a bumpy piece of algae, or even a bland section of sand. Some species are truly masters of disguise, taking camouflage to the next level by mimicking the shape and movement of other animals.

Perhaps the most surprising part of this book is the emotional journey that follows. Montgomery blends science with anecdotes, recounting her own experiences and those of others. These narratives allow us to imagine how octopuses experience their world, what motivates them, and how even individual octopuses have their own personalities and idiosyncrasies. Through these stories, we get a glimpse into the unexpected similarities these soft-bodied critters share with other sophisticated minds, even our own.

Such moments of revelation include examples detailing how octopuses exhibit characteristics we usually reserve for large-brained birds and mammals, notably crows, chimpanzees, whales, and elephants. In particular, octopuses use tools, engage in playful behaviors, learn from different experiences, and even form surprising partnerships with other animal species.

Yet, what astounds my scientific mind the most are the affiliations octopuses form with humans. These soft-bodied critters are usually a fraction of our size, with no shell to protect them, and yet their curiosity and desire to meet and greet people often seems to override any fear or apprehension they might feel.

Early naturalist philosophers such as Aristotle (384–322 B.C.) and Pliny the Elder (A.D. 23–79) considered the curious nature of octopuses

and deemed them to be foolish and simpleminded. Yet whales and dolphins weren't derided when they showed the same curiosity toward humans. Is the historical lack of empathy for octopuses an artifact of their small size or bizarre anatomy, compared with that of cetaceans, or is there more to the story?

OUR PLANET IS HOME to millions of diverse species. Not all of them arouse intense emotions in humans. Feelings of empathy and compassion appear to be heightened for species more closely related to us. Species more phylogenetically distant from us tend to evoke fewer positive emotions.

Research shows our empathetic perceptions are modulated by the knowledge we have obtained about each species. New scientific discoveries have proved that animal species far removed from our own lineage are more similar to us than we once thought. For instance, honeybees use tools, lobsters feel pain, and cleaner wrasse (little blue fish) appear to recognize themselves in the mirror.

Such findings on diverse animal minds shift our perspective by helping remove the barrier of "otherness" and allowing us to connect emotionally with different life-forms.

I think of this shift in perspective as a revolutionary change, much like Nicolaus Copernicus's 1543 discovery that transformed the way we see our world and, critically, our place in it. For centuries, we had believed that Earth was the still point around which the sun, moon, stars, and other planets revolved. But Copernicus published a detailed alternative, replacing Earth with the sun at the center of the cosmos. His findings set into motion a revolutionary shift in perspective. Earth was dethroned as our cosmic center, and modern astronomy was born.

I believe we are at the beginning of a similar revolution. We are realizing that humans are not the only beings with sophisticated minds. Demonstrations of cognitive and emotional sophistication are all around us, even in the most unexpected characters. This monumental shift in perspective provides a radically new understanding of diverse animal minds, not only helping to reshape the way we think about animals, such as the octopus, but also the way we treat them.

The more we reveal the octopus's secrets, the more empathy and compassion we can feel, which in turn fuels a need to protect these enigmatic critters and their fragile ecosystems. *Secrets of the Octopus* is the perfect guide through this transformative journey.

# From Monster

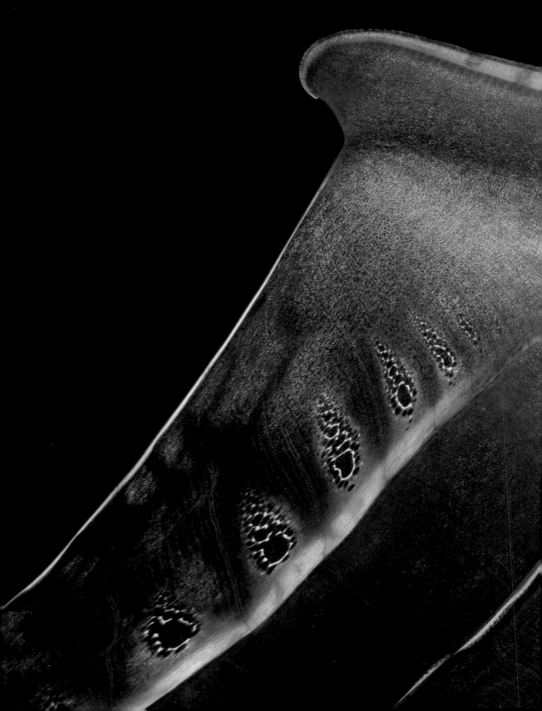

# to Superhero

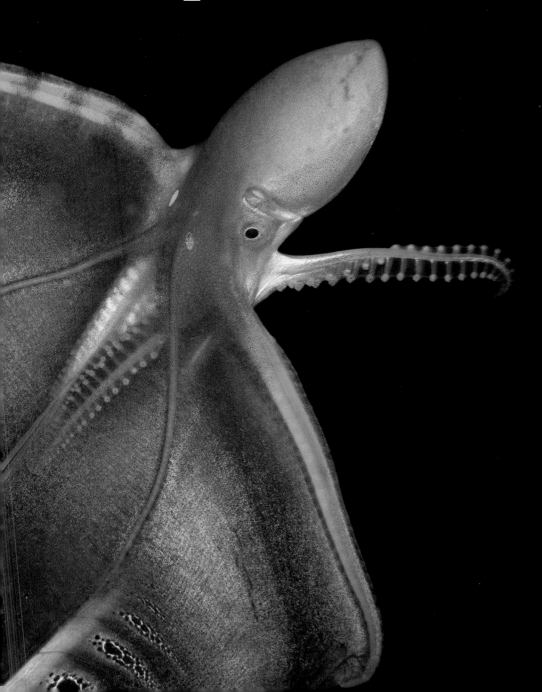

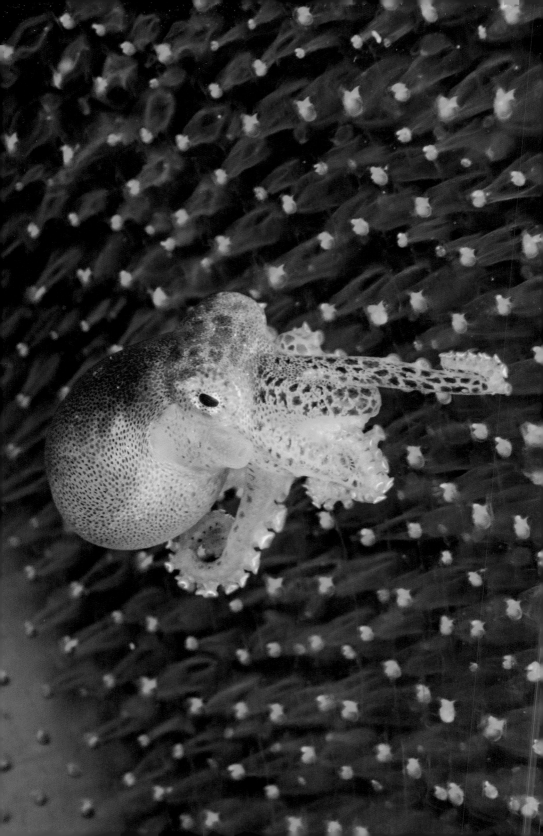

'd never met anyone like Athena before.

Though she was an adult, she was only about four feet (1.2 m) tall. She weighed a mere 40 pounds (18 kg). And she was unusual in several other respects. She could change color and shape, taste with her skin, drool venom, spit ink, and jet about by squirting water through a siphon on the side of her head. Not to mention pour her baggy, boneless body through an opening the size of an orange. Her head wasn't even on top of her body, like mine. That spot was occupied by a body part known as the mantle, containing the organs of respiration, digestion, and reproduction. Her head was where you'd expect to find a torso. And her mouth was in her armpit.

Athena was a giant Pacific octopus, an *Enteroctopus dofleini*.

We met at the New England Aquarium in Boston, when senior aquarist Scott Dowd opened the heavy lid to her tank. Standing on a low step stool, I leaned over the water. The octopus changed from a mottled brown to a bright red with excitement as she spilled her liquid body out of her rocky lair. One of her glittering, silver eyes sought mine as her eight arms boiled up to the surface to meet me. With Scott's permission, I plunged my hands and arms into the numbing, 47°F (8°C) salt water, and I let her engulf my skin with her soft, questing, white suckers. She was both tasting and feeling me at the same time.

Most relationships don't begin with this degree of intimacy. Had a person begun tasting me at this early stage in our friendship, I'd have been alarmed.

---

Most often found on Rapa Iti, an island in French Polynesia, this octopus is called *fe'e mototi*—poison octopus—by locals. Its body measures just four inches (10 cm) in length.

PREVIOUS PAGES: Female blanket octopuses (*Tremoctopus*) can reach six feet (1.8 m) in length. They stretch the webbing between some of their arms to frighten predators.

And I realized, too, that not everyone would have liked being embraced by an octopus.

The water was cold, her skin was slimy, the creature I was touching was venomous—and I soon realized, as well, that when I got home later that day, I would have to explain to my husband why my arms were covered with hickeys.

But I was neither alarmed nor afraid. I was elated.

Athena didn't just welcome my company; she allowed me to touch her head. She had not allowed any visitor to do this before. And once we spent some time together, as she tasted me and I stroked her, she changed color again. She turned white beneath my touch—the color, I later learned, of an octopus who feels calm.

It was clear to me that during our encounter, we had shared an illuminating exchange. Athena, to my surprise, was just as inquisitive about me as I was about her.

"But aren't they *monsters*?" my human friend Jody Simpson asked me the next day as I described my encounter with Athena while we walked our dogs through the woods. Jody was a good friend to many animals. She shared her home with two poodles and a cat. She was an accomplished horseback rider. She loved feeding wild birds. But an octopus? How could you have any kind of communion with an octopus?

Indeed, centuries of Western literature have portrayed octopuses as oceangoing demons. "No animal is more savage in causing the death of man in the water," wrote Roman philosopher and commander Pliny the Elder around A.D. 77, "for it struggles with him by coiling round him and swallows him with sucker cups and drags him asunder." Because they are so different from us, because some species can grow so large (several of the largest have topped 300 pounds [136 kg]), and because of their enormous strength (a single large sucker on a giant Pacific can lift more than 35 pounds [16 kg], and the animal has 1,600 of them), octopuses can

frighten and confuse humans—or at least those humans who don't get a chance to know one.

Nearly two millennia after Pliny, filmmaker John Williams was still dissing octopuses. "A man-eating shark, a giant poison-fanged moray, a murderous barracuda, appear harmless, innocent, friendly and even attractive when compared to the octopus," he wrote. "No words can adequately describe the sickening horror one feels when from some dark mysterious lair, the great lidless eyes stare at one … One's very soul seems to shrink beneath their gaze, and cold perspiration beads the brow."

This is not what happened to me. I welcomed Athena's touch. Her slime coat was silky, like wet custard. Her skin was soft. The feel of her suction cups on my skin reminded me of little kisses. Athena's changing skin, her bridal-white suckers, her alert gaze, her fluid grace: They all dazzled me with alien beauty.

I was mesmerized by her otherness. According to almost every basic classification of animal life, she and I were virtual opposites. She was a protostome—developing as an embryo mouth first. I was a deuterostome, developing back-end first. She was an invertebrate, without bones. I was a vertebrate, scaffolded with a bony skeleton. She lived in water, I on land. She breathed water. I breathed air. The last time her kind and mine had shared a common ancestor, back half a billion years ago, everybody was a tube.

Yet I was also struck by an unexpected sameness. Despite the yawning gap in our taxonomic classifications, it seemed possible that we could have a meeting of the minds. Perhaps we could even be friends.

And then, Athena began pulling me into her tank.

Equipped with hydrostatic muscles, more like those in our tongues than our biceps, an octopus of her size can, by some calculations, resist a pull 100 times her own weight. That would be 4,000 pounds (1,814 kg). I weigh 125 (57 kg). But again, I was not afraid. I felt no malice on her part. Her pull was insistent but gentle. I didn't worry she wanted to eat me. I was comfortably

aware that her beak, located in her armpit, and its adjacent venom glands were nowhere near the arms that were pulling on mine. Her tenacious tug was no threat. Instead, it was an invitation—one I was honored to accept.

ATHENA DID NOT SUCCEED in hauling me fully into her home. I wouldn't fit. Her habitat was ample, but much of it was taken up by hiding places into which she could flow gracefully, but where my awkward, jointed body could not go. Then there was the problem of my missing gills—organs that I, in the way of all mammals, first grew as an embryo but then, as a fetus, lost, exchanged for air-hungry lungs.

But this strange, beautiful, curious creature did pull me into her world—a world I explored for years after her death, and am exploring still. Octopuses, alas, do not live long. Giant Pacifics survive only three to five years, and Athena was already old for an octopus when I met her. But over the course of the next three years, I got to know her successors at the aquarium, Octavia, Kali, and Karma, quite well. I visited every week to watch and feed and stroke and play with them.

All these octopuses quickly learned to recognize me by sight and distinguish me from other humans. Previous experiments at the Seattle Aquarium proved that octopuses do recognize individual human faces. And keepers know well that octopuses, like the rest of us, are highly individual. They like some people and, for whatever reason, dislike others. One person Octavia decidedly did not like was my best friend, Liz Thomas—an animal savant who has studied lions, dogs, deer, and wolves. To my surprise and dismay, when I introduced the two, Octavia withdrew from Liz's first touch, and thereafter wouldn't go near her. (This may have been because my friend was a smoker; invertebrates in general are repelled by nicotine, and though Liz

had washed her hands, Octavia may have tasted the noxious substance in the blood beneath Liz's skin.) I was lucky that the octopuses I met all liked me.

While all of the octopuses I came to know were playful and intelligent, each displayed a distinct personality. Octavia, who replaced Athena after she died, was standoffish at first but became a very gentle, loving, and stalwart friend. One time, after I returned to the aquarium from a few weeks away on assignment, she greeted me with extraordinary enthusiasm. We literally rushed into each other's arms, and once there, she held me, lingering, looking into my face, for more than an hour—just like you might hug a friend from whom you'd been separated for too long. Impetuous Kali, a smaller, younger octopus who lived in a barrel behind the scenes, trained me, and other the humans who tended to her, to hand her a fish the first moment we opened the lid to her container. If we were slow with the meal,

Eighty-eight individual suckers adorn just one arm
of this starry night octopus (*Octopus luteus*).

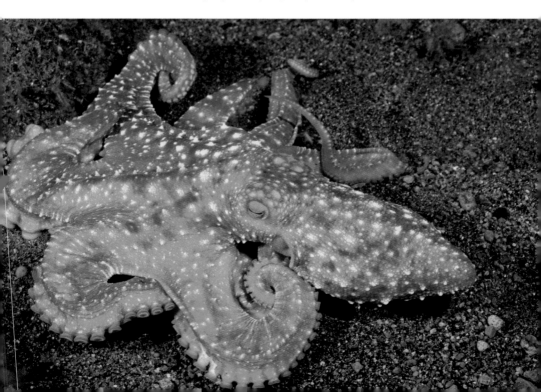

she'd squirt us in the face with freezing cold salt water from her siphon, the flexible tube on the side of her head with which octopuses jet through the sea. Karma, who replaced Octavia after she was gone, was sweet, gentle, and affectionate. Her colors were so mesmerizing that I think my friend, fellow aquarium volunteer Wilson Menashi, had a crush on her, even though he was happily married to a human female.

I wrote of my friendships in a book published in 2015. Its title, *The Soul of an Octopus,* gave some readers pause. How can an octopus have a soul? (Many scientists and philosophers don't believe in souls; some believe humans don't even possess consciousness—that it's just a made-up concept to help us handle the pointlessness of existence.) Octopuses are mollusks, relatives of brainless clams. Surely, some said, suggesting an octopus might have a soul, or a personality, or thoughts or memories or emotions, was simply a product of a misguided human propensity to anthropomorphize animals, to wrongly attribute "human" feelings to non-human creatures, like a child pretends that a doll is really alive.

These folks are mistaken. Yes, it's easy to project your own feelings onto an animal—or a human, for that matter. Who hasn't erred in this way? We have all picked the wrong gift for a treasured friend, or told a joke we thought hilarious that fell flat, or asked someone out on a date, only to be rejected. Just like other people, other animals don't always share our point of view. Otherwise, fish would try to escape from the water, and your dog wouldn't sit on the living room carpet and, surrounded by company, proceed to unabashedly lick his privates. Animals are not merely people repackaged in fur, feathers, and scales. Unlike a lion, I don't have to kill my food with my teeth and claws, and unlike a vulture, I do not repel intruders by projectile vomiting upon them.

But the attitude that animals are automatons without thoughts or feelings is an idea behavioral scientists increasingly recognize as being as outdated as Pliny's *Naturalis Historia.* (Actually, though Pliny thought octopuses

mean and stupid, he didn't consider them mindless, and he did not believe only people think. That idea dates to a later French philosopher, René Descartes, and his famous declaration *"Je pense, donc je suis"*—"I think, therefore I am"—in 1637.) Jane Goodall's discoveries that chimps are smart enough to fashion tools, and their personalities distinctive enough for individuals to merit names, trashed the notion that humans alone possess mental experience. Science has since accumulated masses of data that support what many of us knew all along: that animals, from elephants and dolphins to fruit flies and cuttlefish, think, feel, and know. Even—and perhaps especially—octopuses.

I began my relationships with octopuses without expectations. I knew so little about them—not even that I had been using the incorrect plural, "octopi," all my life. (The reason: "i" is a Latin ending denoting the plural, but "octopus" is a Greek word.) But even with my beginner's mind, the octopuses I met astounded me again and again.

The stories I shared of Athena's pointed curiosity, of Octavia's devotion, and of Karma's gentleness resonated with readers around the world. When Kali crawled out of her tank through a tiny hole in the lid and died, dozens and dozens of readers wrote me that the scene left them in tears. To everyone's surprise, a book about a marine invertebrate few people ever met outside of an aquarium became a national bestseller within weeks of publication. The book was also a finalist for a prestigious literary prize, one rarely awarded to natural history books, and it has been translated into more than a dozen languages.

In New York City, then 27-year-old Warren Carlyle met Athena, Octavia, Kali, and Karma on its pages. He had adored octopuses since he was seven. "I couldn't believe the world still hadn't caught on to the wonder of these

FOLLOWING PAGES: Two day octopuses (*Octopus cyanea*)
fight near the Red Sea's Gubal Island.

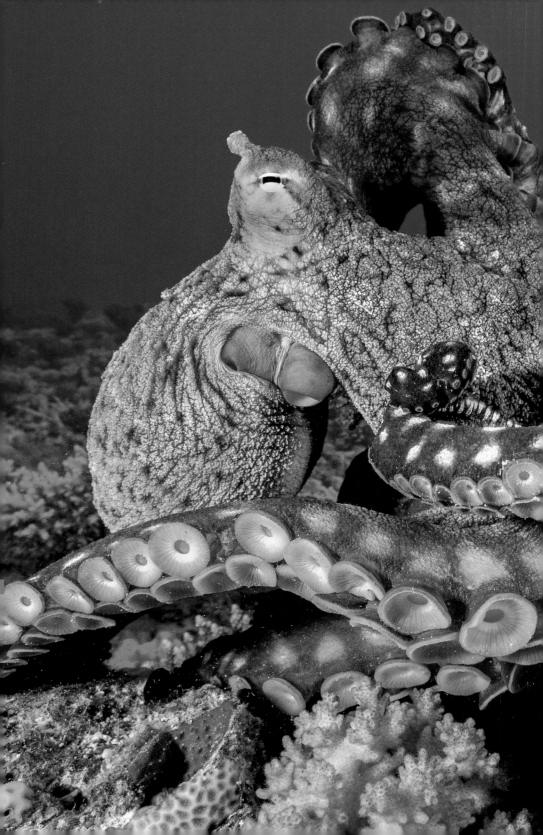

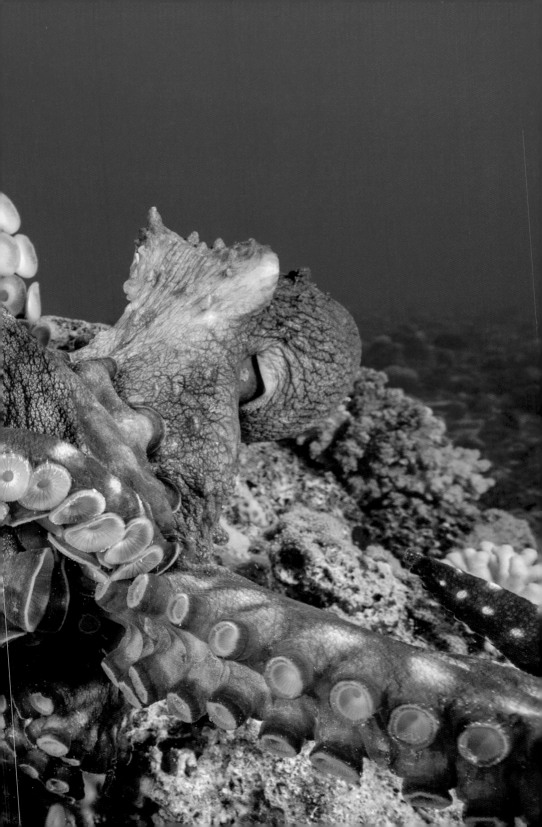

brilliant animals," he says. Instead of monsters or villains, he considered them "superheroes of the sea." As he closed the book's covers, he made a vow: "I was going to tell the story to all the world of this incredible creature, to spread the news of its ecological impact, to foster love for the ocean through the lens of the octopus." Working in New York as a studio manager for a celebrity fashion photographer (now he runs a brand management agency), he realized that he had the skills to boost the octopus's profile. In December 2015, he launched OctoNation, an online octopus fan club and educational organization. Drawing on the considerable resources of "The Nation," Carlyle contributed the octoprofiles for this book.

Today he has seven Ph.D. octopus experts on his nonprofit's payroll, and OctoNation boasts one million members across all social platforms. This year, OctoNation's content—from scientific news about octopuses, photos and videos of octopuses the world has never seen before, extensive back-grounders on octopus species, stories of people's encounters with octopuses, conferences, virtual field trips to aquariums around the world, and special pages for kids—engaged half a billion viewers.

A day octopus (*Octopus cyanea*) swims off the coast of Anilao, Philippines.

"OCTOPUSES ARE HAVING A MOMENT," agrees Dr. Christine Huffard, a senior research specialist at the Monterey Bay Aquarium Research Institute in California. She should know: She has spent 20 years studying the animals, but some of her mentors initially dismissed her important, early observations, including the surprising discovery that some octopuses walk around upright on two limbs. She remembers a colleague's groundbreaking work— reporting an entirely new species and social arrangements never before suspected among octopuses—that went unpublished for decades, rejected by journal editors who thought "nobody was interested in octopuses."

Carlyle remembers the same sad situation when he was growing up. As a neurodivergent kid, he was "obsessed" with octopuses from the moment he first saw one in an aquarium. But he could find no octopus toys, or octopus art, or octopus books. He was desperate to find out more about them, but to his frustration, he could find nothing to read. "There were hundreds of books on dinosaurs, and they don't even exist anymore! How is it possible," he wondered, "that nobody has written a field guide to my favorite animal?" (OctoNation is working on that now.)

When Carlyle was starting OctoNation, even his brother questioned his vision. "He said, 'Maybe you should choose an animal that's going extinct,'" he recalls. "'Maybe octopuses are too niche.'"

Once, that was true. But things have changed.

I remember being thrilled when, to celebrate the publication of my book, Scott Dowd, who had first opened Athena's tank for me, managed to score the extraordinary gift of a mug decorated with the image of an octopus. "How did you ever find such a thing?" I wondered. He had looked far and wide.

Today, octopuses are everywhere. The Unicode Consortium added an octopus emoji in 2015. OctoNation's octopus stickers and stuffed animals,

sold on OctoMerch.com, are so wildly popular that their sale funds much of the club's work. Octopuses are celebrated in public art, from the 20-foot-tall (6 m) sculpture of a purple octopus named Ocho presiding over a park in East Austin, Texas, to the inflatable blue octopus arms sticking out of the windows of the Philadelphia Navy Yard in a 2018 installation, to the 55-foot-tall (17 m) stainless steel octopus looming over the Branson Aquarium in Missouri.

Ceph lovers can now surround themselves with suckers. There are not only plenty of octopus mugs and octopus T-shirts, but also octopus hats and scarves and earrings and necklaces and socks; rings for fingers, noses, and toes; and tentacles for everything from hands to high heels. Online you can scroll through pages of octopus designs for your computer accessories, from mouse pads to cell phone cases to phone stands, and you can tote them around in your octopus backpack. You can easily outfit your bathroom in a cephalopod theme, with octopus shower curtains, octopus towels, octopus bath mats, octopus-shaped soap, octopus toilet paper holders. You can fill your whole house with octopus furnishings: octopus pillows, bedspreads, mirrors, coatracks, tables, chairs, lamps, bookends, chandeliers, candelabras, plates, bowls, tablecloths, napkins, napkin holders, cutlery, and stemware. (I know, because many of these items are in my house.)

Sitting on your octopus-shaped sofa (yes, there are several models of these), you can draw from your bookcase (one adorned with octopus shelf decor) any of several excellent new nonfiction titles about octopuses. Though a handful of fine books on octopuses were available while I was researching my book (such as *Super Suckers: The Giant Pacific Octopus and Other Cephalopods of the Pacific Coast* by Jim Cosgrove and *Octopus: The Ocean's Intelligent Invertebrate* by Jennifer Mather), they were published by small or academic presses and not widely available. But in 2016, *Other Minds,* written

An Atlantic longarm octopus (*Macrotritopus defilippi*) can have arms seven times the length of its body.

by diver/philosopher Peter Godfrey-Smith, which uses the example of the octopus to explore the ancient origins of consciousness, found such a wide audience it became a bestseller. Likewise for Dr. David Scheel's 2023 *Many Things Under a Rock,* in which the Alaskan ecologist relates his surprising discoveries and adventures with octopuses.

Octopus novels have squeezed their way onto fiction bestseller lists, too: 2022's *Remarkably Bright Creatures* by Shelby Van Pelt tells the story of a widow's friendship with an aquarium octopus. In Germany, drugstore magnate Dirk Rossmann's eco-thriller *Der neunte Arm des Oktopus* (*The Ninth Arm of the Octopus*) spent more than 18 weeks on the 2021 bestseller list. To my amazement and delight, I am actually a character in that book— one who, in this fictional narrative, introduces Vladimir Putin to an octopus at the New England Aquarium, in an effort to foster international cooperation on climate change! And there are now many children's books featuring octopuses (I've written two of them).

No longer cast in movies as villains, octopuses today are celebrated cinematic heroes. Hank the octopus charms viewers as he changes colors, shoots ink, and schemes to outwit humans in order to help Dory, the regal blue tang, reunite with her family. Hank's appealing character also helped make Disney's film *Finding Dory* the third highest grossing film of 2016 worldwide, and, at the time, the fourth highest grossing animated film of all time. In the 2019 PBS documentary *Octopus: Making Contact,* ecologist Scheel invites a day octopus named Heidi to share his home. The show garnered 1.9 million viewers for its premiere. A sequence from the film in which a sleeping Heidi twitches, jerks, and changes color—appearing for all the world to dream—went viral on the internet. That success was followed by the blockbuster *My Octopus Teacher,* the 2020 documentary aired on Netflix about free diver Craig Foster's yearlong friendship with a wild octopus in the kelp forest of South Africa. It won an Academy Award. And now, National Geographic's award-winning *Secrets Of* franchise returns

with a new series, *Secrets of the Octopus,* streaming on Disney+. From SeaLight Pictures, this around-the-world project took almost two years to film, involving 1,500 people-hours underwater with the animals—resulting in never-before-seen footage of octopuses showcasing an intelligence that, 10 years ago, nobody would have believed possible.

More important than the (admittedly, welcome) proliferation of octopus-themed products, and surely as transformational as the animal's recent impact on the arts, is the current explosion in octopus science. Discoveries are coming fast and furious. The first octopus genome (that of the California two-spot) was sequenced in 2015. In 2017, researchers with the Marine Biological Laboratory in Massachusetts and Tel Aviv University reported the discovery that octopuses, and their relatives the squid and cuttlefish, can *edit their own RNA,* the messenger carrying instructions for the synthesis of proteins from DNA. They can actually recode the genes important to their nervous systems—an extremely rare ability that may well have to do with their unusual and extraordinarily well-developed brains. In 2022, University of Chicago researchers reported the discovery of a novel neural structure with which the arms on opposite sides of an octopus are connected. "We think this is a new design for a limb-based nervous system," the lead researcher reported.

A statistical analysis of articles in major scientific journals published around the world confirms a dramatic uptick in octopus-focused research. A trio of Italian researchers, reporting their work in the journal *Animals* in 2021, shows that, in 1985, fewer than 10 papers a year were published on the octopus. In 2020, the last year these data were collected for the study, there were more than 100—a tenfold increase, on a trajectory that is steadily rising. The authors of the study considered 2011—the year I met Athena and began my own investigation—as the "cutting edge" dividing the "earlier period" of scant interest from

FOLLOWING PAGES: A glass octopus (*Vitreledonella richardi*) explores the deep open ocean off Cape Verde.

the "recent period" of discovery. The recent period, they found, also was marked by a "sharp" increase in the number of authors collaborating on papers, coming from an increasing number of countries and affiliations.

Why are octopuses suddenly in the scientific spotlight? Dr. Chelsea Bennice, a Florida-based marine ecologist specializing in octopus behavior, notes that octopuses' incredible abilities and unusual talents offer fodder for many scientific disciplines. "I like to think about the octopus as our scientific advisor," she says. "By studying their ecology, behavior, and genetics, we can answer questions related to ocean biodiversity and health, sustainable fisheries, evolution, bio-inspiration for soft robotics and neuroscience—and for me, a scientific researcher, educator, and communicator, how to be an excellent multitasker!" Known to her community as "Octo-girl," she serves as a scientific advisor to OctoNation in addition to her teaching, lab work, and field research.

She also notes that more snorkelers and divers than ever are now able to meet and observe octopuses in the wild. Thanks to advances in video technology, many also are able to document their observations—providing intriguing clues to octopus behaviors for scientists to investigate. Bennice is the inventor of the Octopus Monitoring Gadget—also known as the OMG—that for the first time allows researchers to record video of octopus behavior continuously in the wild for 24 hours. With its waterproof housing, red light (for nighttime footage, which doesn't bother the octopus), and long-lasting battery, the OMG is proving a revelatory tool. I recently saw footage it had gathered of a common octopus (*Octopus vulgaris*) about the size of a basketball being attacked by a diving cormorant. The sudden appearance of this marine bird, with its long, sharp beak looming large as the spire of the Empire State Building, in comparison with the soft octopus, seemed as menacing as an attacking mosasaur. Without a shell to protect it like its fellow mollusks, the squishy octopus seemed pathetically vulnerable. I'd have thought it would have dived into its den for protection, or jetted

away, or used its camouflage to become invisible. To my astonishment, when confronted by the avian predator, it did none of the above. Instead, the brave little octopus stood firm and, aiming directly at the monster above, raised one of its nearly liquid arms to take a swing at it. OMG!

On the island of South Caicos in the Caribbean, cephalopod ecologist Dr. C. E. "Shades" O'Brien is using the OMG to film four species of octopuses in the wild while they are awake and also while they are asleep. Using the device, O'Brien is building on the intriguing laboratory studies of neuroscientist Dr. Sylvia Lima de Souza Medeiros, which suggest that octopuses, like humans, might experience dreams.

Advanced technology was crucial, too, for SeaLight Pictures' camera crew when filming the series for National Geographic. The crew was able to utilize re-breathers—diving apparatuses that recycle unused oxygen in the divers' exhaled carbon dioxide—enabling the team to stay down observing a single animal for more than four hours at a time. With as many as six different camera systems on the bottom for these extended dives, they were able to capture behaviors never before reported.

In-depth, up-close video recordings and scientific investigations like these are utterly new since I first met Athena. Still other researchers are building upon important work that has been going on for decades. Their imaginative experiments, acute observations, and mind-blowing discoveries are the inspiration for the pages you are about to read. In some cases, new studies are answering some of the questions I had when I was getting to know Athena, Octavia, Kali, and Karma. For instance: Why did these octopuses bother to enter into a relationship with me at all? What would cause them to literally reach out to another creature—especially one so different from them as I?

While filming *Secrets of the Octopus,* series director and director of photography Adam Geiger experienced this same wonder. "What struck me, and all of our team, across the different species of octopuses," he said, "you have the sense of observing an intelligent animal deciding whether to let

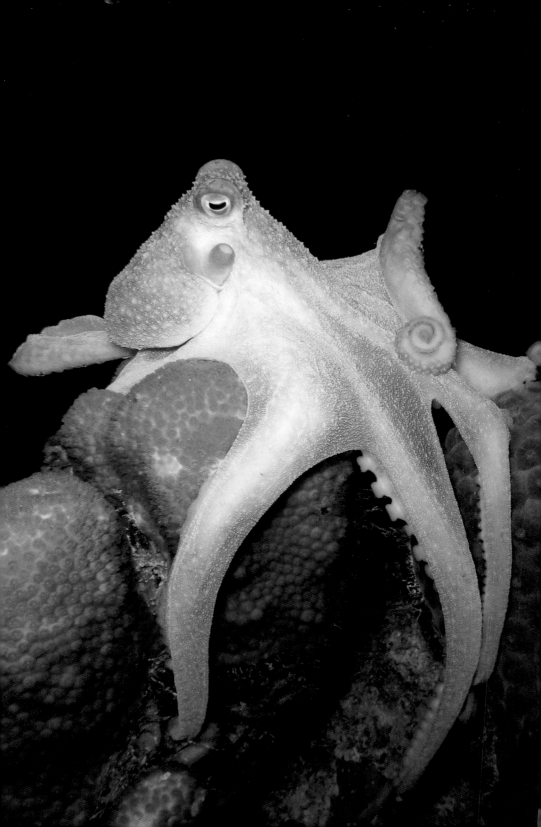

you into its world. And once it decides you're OK, it lets you in. Most wild animals might ignore you or they leave, unless you are hidden by a hide or a blind. But the octopus allows this huge, possibly dangerous animal—a diver—to get close to it and will even reach out to touch you. It's absolutely remarkable. They are incredibly engaging."

For decades, octopuses were thought to be famously solitary, shunning even their own species, except to mate. But stunning new findings now suggest that some of the most basic assumptions scientists made about octopuses' lives may be wrong.

In some cases, new science bears out some of my own intuitions back in 2011. Despite our wildly divergent evolutionary ancestries, our disparate lifestyles, our dramatically different bodies, I felt strongly that my octopus friends' minds worked in a way surprisingly similar to my own. We both enjoyed solving puzzles. We both learned how to use various tools. We remembered past events and learned from them. Researchers' observations and studies of the various aspects of octopus intelligence are building up an ever more impressive résumé of intellectual accomplishments for these big-brained mollusks. In ingenious experiments, wildlife scientist and science communicator Dr. Alex Schnell has demonstrated that the brains of octopus relatives, cuttlefish, are capable of admirably advanced executive functions—comparable to those of chimps and crows.

Huffard is undoubtedly right. Octopuses *are* having a moment, and maybe more than a moment. Perhaps they have brought us to a turning point. As the stories on these pages show, octopuses are revealing to science a totally different path from our own that leads to advanced intelligence. If we follow that path, it may lead us further still, bringing us closer to understanding the shared experience of what it means to think, to feel, and to know.

---

The Caribbean reef octopus (*Octopus briareus*) emerges at night to forage for food. Its iridescent skin becomes a shimmery parachute that can ensnare prey.

# Masters of

# Camouflage

## SHAPE-SHIFTERS OF THE SEA

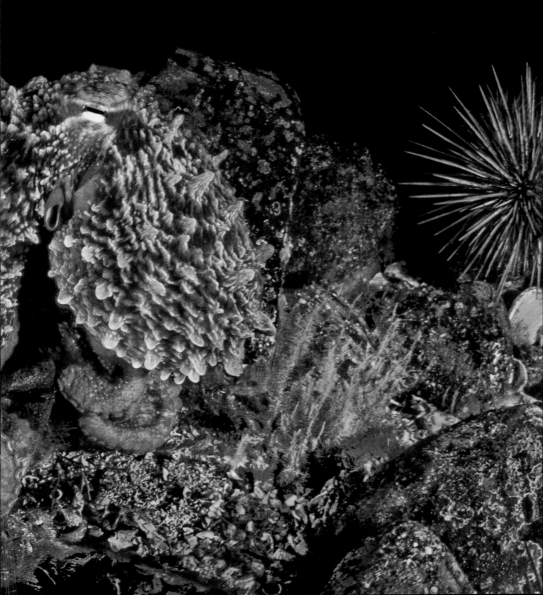

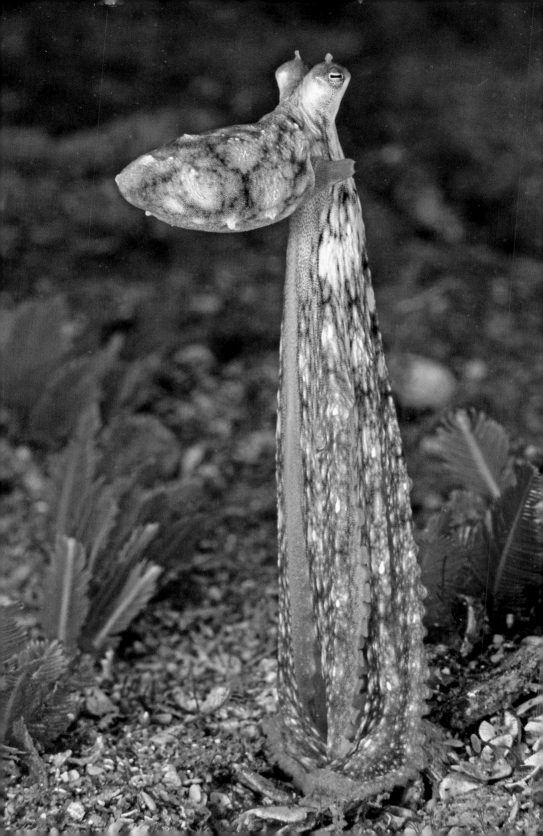

n the shallows of the Caribbean Sea, a clump of unremarkable, brownish green algae sways lifelessly in the current. Inches above the sandy bottom, a small, cigar-shaped fish glides by, U-turns, swims back. It's the sort of scene that most divers and snorkelers, seeking something more interesting—a sea turtle, a shark, a shoal of neon-bright parrotfish—would swim past without a second glance.

Abruptly, the landscape shifts. A section of the middle third of the algae swells, brightens, billows; mottled brown blanches white, and the ruffled surface sleeks smooth. In less than two seconds, a giant, living bubble, round and pale, inflates to triple its size. Large eyes bloom from the white mass, dramatically ringed in black, as the bulbous animal balloons larger still. Like something from a fever dream, the tiny clump becomes animal. This creature does not emerge from *behind* the algae: It *is* a piece of the algae, transformed. A listless organism *becomes* a speedy, nimble, quick-witted being—one who, thanks to its otherworldly powers, now breaks free of its earlier self, like a spirit leaving a body—and shoots away behind a cloud of dark ink.

Such a feat would seem impossible. And it is, for anyone but an octopus.

Marine Biological Laboratory senior scientist Roger Hanlon remembers that, when he surfaced after his snorkeling sortie that day, he was "screaming bloody murder." His research team knew the water was shallow, the sea was calm, and the charismatic professor had safely logged tens of thousands

---

An Atlantic longarm octopus stands on its lengthy limbs near Riviera Beach, Florida.

PREVIOUS PAGES: A giant Pacific octopus uses camouflage to merge with the surrounding red urchins and coral reef.

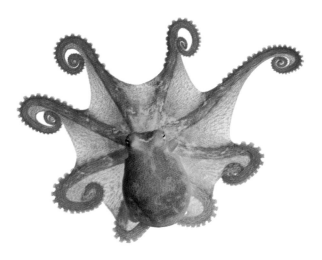

of hours on scuba and snorkel over the course of decades of research. But he made such a commotion, he scared them half to death. "They thought I was having a dive accident," he recalls.

Instead, Hanlon was having a eureka moment. He had been videotaping the most studied of the more than 300 octopus species on Earth, one so widespread and considered so ordinary that its scientific name, *Octopus vulgaris,* means "common octopus." And yet he had just recorded something never seen before. Since then, hundreds of thousands of people have viewed his video. But still, even at Hanlon's scientific lectures, some turn to a companion to ask, "Is that real?"

Boneless, venomous, and equipped with eight powerful, suckered arms (a single large sucker on the largest species, the giant Pacific, can lift 35 pounds [16 kg]—and there are 200 on each arm), octopuses are gifted with talents that seem so otherworldly you'd need to go to outer space or science fiction to match them. Octopuses can taste with every inch of their skin. They can squirt ink to serve either as a smokescreen or as blobs, called pseudomorphs, that look so delicious that turtles have been fooled into biting at them. They can drool a muscle-dissolving acid and a neurotoxic

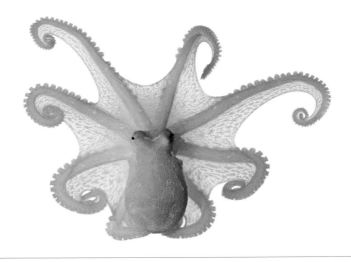

Two southern keeled octopuses (*Octopus berrima*)
demonstrate their species' distinctive color-changing abilities.

venom, and females can exude a glue for attaching strings of eggs to the roofs and sides of their lairs.

But the octopus's hallucinatory ability to change color and shape is its signature superpower—one it can deploy faster than a human can blink an eye.

Hanlon's video of the common octopus provided only one example among a recent tsunami of stunning observations and discoveries about these ancient, shape-shifting invertebrates. Despite its name, the common octopus's transformative talents are anything but common, but those of the day octopus (*Octopus cyanea*) are yet more elaborate. Hanlon considers the day octopus the "king of camouflage." The species thrives in the coral reefs of the Indo-Pacific—one of the most complex habitats on Earth, and one teeming with textures and colors and a vast array of keen-eyed predators and prey. Reviewing videotapes of these big octopuses from Micronesia and French Polynesia, Hanlon calculated they can change color up to 177 times an hour and assume 50 different body patterns. And though they can change color in one-fifth of

a second, they can also maintain some of their colors and patterns steadily for more than an hour. "The speed and diversity" of these transformations, says Hanlon, are "unmatched in any animal we know of."

Octopus disguises run more than skin deep. In their effort to conceal their identity, one species rolls around the ocean floor like a sunken coconut. Others resort to acrobatics yet more exotic. One Indo-Pacific species has been filmed holding six arms aloft, while using the other two to stride along the sandy bottom—looking to human viewers like a frazzled commuter who's forgotten a briefcase.

Many animals, of course, employ the art of camouflage. Foxes and ermines turn white as snow in winter; insects mimic leaves and twigs; when excited or frightened, chameleons change from their usual, uniform brown to a kaleidoscope of patterned colors, from carmine to turquoise. Some creatures change their appearance to startle predators. Certain moths flash their underwings, revealing spots that look like huge eyes, and mammals from cats to chimps raise hackles to look bigger than they really are.

But in octopuses—and their relatives, such as cuttlefish and squid—the transformations are so varied and convincing, it's jaw-dropping. They will even mimic the weather. One display common to a number of octopus species is called "passing cloud." An octopus produces a wave of darkness on its skin that slowly washes over its body, like a shadow cast by a cloud moving overhead. It's thought that the octopus creates this illusion to induce a prey item like a crab to move, without the octopus having to give away its location by moving itself. "The level of complexity" of such displays "is astounding," asserts Hanlon.

No wonder as many as one-third of the world's known species of octopuses have been observed so rarely that they have barely been studied at all. Their disguises are so effective that they deceive animals as diverse as seals, whales, birds, sharks, and crabs—as well as scientists. Researchers are now discovering that octopuses they have been studying for decades

turn out to be a completely different variety than what they thought—resulting in a slew of reports of species new to science.

It seems fitting that the oldest known fossil ancestor of octopuses and squid sat unnoticed in a drawer in a Canadian museum for 30 years. Only in 2021 did researchers realize that a slab of limestone from Montana contained a 10-armed creature with well-preserved suckers that could push back the known evolution of octopuses by 82 million years. They named it *Syllipsimopodi* (which means "prehensile foot") *bideni* (honoring the newly inaugurated president). It's the only member of its genus.

So now we know that octopuses and their kin have been perfecting their magic for at least 328 million years. Like scallops, oysters, clams, and snails, they are mollusks, members of an ancient phylum that arose in the earliest Cambrian, before the evolution of the trilobites. One group of mollusks arose who could swim: the cephalopods. (The word means "head-foot"—appropriate because the limbs are attached to the head rather than to a torso, as is the case with us.) All cephalopods have arms or tentacles and blue blood, and possess a siphon, or jet, in the head with which they can shoot through the sea. The first cephalopods had shells, as does the nautilus today. But the group also includes the more recently evolved and shell-free cuttlefish, squid, and octopus.

Tentacled, shell-less mollusks were already jetting through the world's oceans 76 million years before the Permian extinction killed off 90 percent of all life on Earth. That's 198 million years before plants learned to flower and 262 million years before the asteroid wiped out the dinosaurs. Throughout the relatively short period that our upstart species has been venturing into their oceans, octopuses have been morphing right under our noses. Many divers have spent hundreds, even thousands, of hours underwater but have never seen an octopus. Or so they say. They probably have—they just didn't know what they were seeing. Which, from the octopus's perspective, is exactly the point.

IN THE MUDDY, near-shore waters of the Indo-Pacific, a 10-inch (25 cm) beige octopus sprawls invisibly on the sandy bottom, its thin, spidery arms concealed in the matching substrate. Abruptly, its round mantle—which contains most of the animal's internal organs, but sits *above* the head rather than below—begins to pulsate like a beating heart (of which the octopus has three). As the gills draw in oxygenating water, large, alert eyes rise and rotate. The head sprouts tall, thin "horns" (actually erectile structures known as papillae), and the spindly body rises from the sand. The skin flashes bold mahogany-and-cream stripes arrayed like those on an old-timey prisoner's uniform. Still resting on the sand, the conspicuous arms

This mimic octopus (*Thaumoctopus mimicus*) seems to have taken the shape of a flounder to disguise itself from predators.

thicken, curl, bunch—and then, liftoff! As water jets through the funnel at the side of its mantle, the creature shoots away through the sea, trailing its banded arms behind like streamers.

The mimic octopus (*Thaumoctopus mimicus*) is on the move.

Though the animal's range is now known to be vast—stretching from the Red Sea to New Caledonia, from the Gulf of Thailand to the Philippines, and all the way south to the Great Barrier Reef—until recently, scientists did not know the species existed at all. It wasn't fully described until 2005. Why? Locals knew about the creature. But to scientists and outsiders, the landscape seemed so boring, with little to see but mud and sand, they rarely ventured there. The few visitors who did come seldom noticed the octopuses, because most of the time, these small animals rest concealed in the sand, with only their eyes exposed.

But you can't stay hidden and immobile forever. The mimic must travel to find the small crustaceans and fish it eats. Other octopus species, hunting among rocks, corals, and algae, can melt their bodies into crevices to hide from predators. They can camouflage themselves to look like their background. Or they travel by night in the dark. But the mimic octopus roves over a relatively featureless landscape of open sand flats, and it does so during broad daylight.

So instead of blending in, it stands out.

The mimic is not the only octopus to do this. Ten species of blue-ringed octopus (*Hapalochlaena* spp.), found from the Sea of Japan to the waters of South Australia and from the Philippines to the island nation of Vanuatu, also adopt this strategy. They look dull gray or beige when resting. But if they're threatened, their skin flashes bright with up to 60 neon blue, iridescent rings, set off by black outlines on a cream or yellow background. Like the lights on an ambulance or police car, the rings pulse to ensure they capture attention. These octopuses are advertising a weapon. With the help of symbiotic bacteria that live in their salivary glands, they possess a

neurotoxic venom one thousand times more deadly than cyanide. Their lives depend on potential predators heeding their warning to stay away.

But the mimic octopus lacks the blue-ringed's potent venom. When it turns on its bold pattern and bright colors, it is, instead, telling its predators a convincing lie—a lie tailored to the differing fears of various kinds of hunters.

Wearing its bold bands, the mimic can travel under a variety of disguises. It can undulate along the muddy bottom, holding its trailing arms behind—assuming the same configuration, coloration, movement, and speed of a poisonous flatfish known as a zebra sole. Or it can swim higher in the water column, with all arms stiffly extended, like the poison-tipped spines of a lionfish. The disguises seem to work. Researchers have watched in awe as a mimic octopus, approached by a damselfish—a species so aggressive it's known to chase away barracuda—changes into the shape of another creature before its predator's eyes. Inside of one second, the mimic hides six of its arms in the sand and extends only two of its serpentine, striped limbs, rippling them in opposite directions. The damselfish flees—just as it would if threatened by one of its deadliest enemies, a boldly striped, venomous banded sea snake.

Tipped off by local fisherfolk and divers, University of Melbourne marine biologist Mark Norman led the Australian and English research team that reported the scientific discovery of the mimic in 1998. The team first encountered the species at the bottom of a river mouth off the coast of Sulawesi. Norman had previously reported more than a hundred new species of octopuses. But he'd never seen an octopus pull off masquerades like these.

"The first time I saw it, I was really blown away," he says. "It really is the pinnacle of wizardry. You couldn't get a more spectacular animal." (And then, in 2018, Norman found another species, a similarly colored and talented impressionist sharing a similar range, but sporting a head that often appears Y-shaped and a candy-cane pattern of reddish-brown-and-white stripes. Realizing its potential to excite underwater photographers, Norman dubbed the handsome new species *Wunderpus photogenicus*.)

Norman and his colleagues have seen the mimics assume so many guises that they've spent entire nights arguing over exactly which creature a given octopus was attempting to conjure. The list of animals the species may mimic now numbers 15, and includes anemones, jellies, brittle stars, mantis shrimp, crocodile snake eels, and sea slugs. There may be more.

"Sometimes it's hard to interpret what's going on," Norman admits. When the mimic bunches its body into a fat cone, with what looks like jointed legs and a chitinous head out front, some see a good imitation of a hermit crab. Others aren't so sure. But the mimic only assumes that pose at one time of day: in the afternoon, when hermit crabs are active. Mimics' flounder impersonations are so convincing that actual flounders have been spotted following them.

Alex Schnell, a comparative psychologist based in Sydney and a producer of National Geographic's *Secrets of the Octopus* TV series, is especially intrigued by the mimic's many deceptions. Ever since she met her first octopus at age five (she spent her childhood, as she puts it, "head down, bum up, in a rock pool" at the beach outside her Sydney home), she's been fascinated by these squishy shape-shifters. As a research fellow of Darwin College and a research associate in the Comparative Cognition Lab at the University of Cambridge, she has a special interest in psychology and animal communication.

"What's really interesting," Schnell says, "is the mimic's behavior suggests it's driven or governed by sophisticated cognition—it's not a reflex like a blush." It's possible, she notes, that the blue-ringed octopus flashes its colors as an involuntary response when threatened, like a person's face turns red with embarrassment, or a heart races with fear. The mimic, though, appears to be making a flexible choice—and tailors that choice to ignite the particular

FOLLOWING PAGES: A common octopus (*Octopus vulgaris*) battles a moray eel. The eel is attempting to knot itself in a maneuver that could free it from the octopus's clutches.

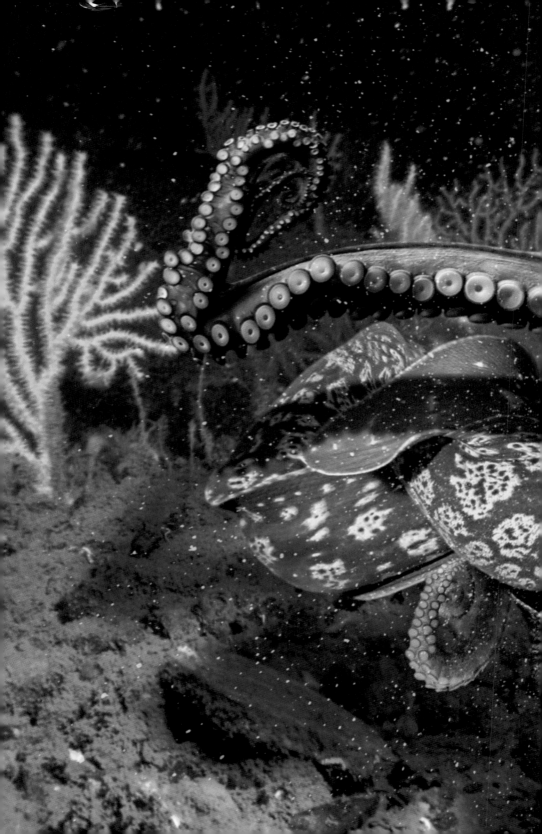

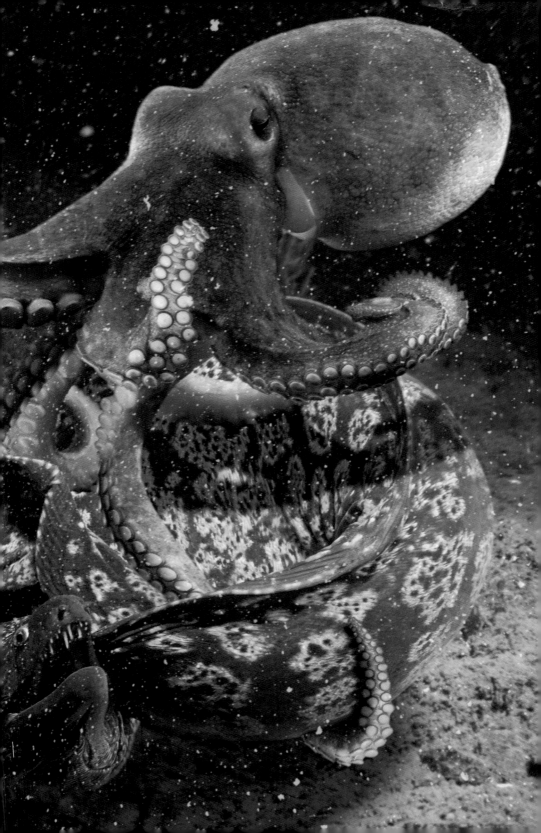

terror specific to each different kind of predator it encounters. "We haven't tested this, but it appears that the octopus may be taking on the perspective of its audience," says Schnell—and, equally important, understands that its audience may have a completely different perspective from its own. "This," she points out, "is hugely complex!"

"Perspective-taking is often confined to human cognition," she continues, "but behavioral hallmarks of this ability have been demonstrated in chimpanzees and members of the crow family. The baffling piece of the puzzle is that perspective-taking is regarded as a trait that evolved in social species. But an octopus is considered a solitary animal. Could this social intelligence trait emerge in the solitary octopus?"

Today, in laboratories and in the underwater wild, researchers are revealing the secrets of how octopuses change their color, texture, shape, posture, and movements to do far more than match their background. Octopuses and their kin also use this superpower to outwit their prey and to communicate with other octopuses—with perhaps greater complexity, precision, and ingenuity than researchers previously dared imagine.

YOU COULD ARGUE that octopuses have the toughest job in the ocean.

Unlike fish, they have no hard bones or sharp spines to protect them. Unlike lobsters, crabs, clams, and sea stars, they aren't shielded by a rigid, external skeleton. And unlike almost all of their fellow mollusks, they have no shell.

This makes them a delicious packet of unprotected protein in an ocean full of hungry jaws.

Everyone eats octopuses. When they hatch, they're the size of a grain of rice, so small they can be consumed as zooplankton by filter feeders such

as baleen whales, manta rays, and whale sharks. Fish slurp them down whole. Even when they grow larger, they're surrounded by predators from every direction, creatures of vastly differing forms and talents. Birds from petrels to penguins dive for them from above. Sharp-toothed moray eels slide into their dens to eat them. Whales, dolphins, otters, sea lions, and seals tear them limb from limb. Even an adult giant Pacific octopus, a species that can grow as large as 20 feet (6 m) across, isn't safe from sharks, orcas, and sperm whales. Ling cod, growing up to 80 pounds (36 kg) with huge mouths containing 18 large, sharp teeth, attack octopuses to usurp their dens. Humans, too, hunt octopuses, harvesting some 3.3 million tons (3 t) a year. Some are eaten, and others—cut up live—are used as squirming bait to catch other species. Even octopuses eat other octopuses with disturbing frequency—both other species, when they can find them, and smaller individuals of their own kind.

It would be difficult to imagine a more vulnerable creature. And yet, it's this vulnerability that has sculpted octopuses' shape-shifting superpowers. Theirs is "a remarkably highly evolved, sophisticated, and beautiful system," the bespectacled Hanlon likes to tell his students. "It's a little bit of art and science blended together … They have solved their problem by changing their appearance." And to do this, when the evolutionary ancestors of octopuses shed the shells of their forebearers, they developed what Hanlon calls "electric skin."

Seen under magnification, the top layer of a live octopus's skin looks like an artist's palette—but one in which the blobs of color can pulsate, swelling larger, shrinking smaller, throbbing with intensity one minute and fading the next. Each blob of color is actually a tiny organ filled with pigment cells—black, brown, orange, red, and yellow—called a chromatophore. Cephalopods may have tens of thousands or even millions of them, and octopuses typically have more per square inch than their close relatives, squid and cuttlefish. A common octopus has more than five million

chromatophores around each eye alone, with which it can conceal or enhance the appearance of the skin surrounding this crucial organ, creating a kaleidoscope of patterns, including rings, stripes, and starbursts.

Other animals—some fish, frogs, and lizards, for instance—also have chromatophores. But cephalopods alone can change the very shape of these organs. Each one of these tight little sacs of pigment is controlled by 18 to 20 muscles. Pulling a sac open widens the disc of color. Relaxing the muscles slams it shut and renders the color invisible. By contracting some muscles and relaxing others, the octopus can control not just the size but also the shape of each chromatophore, creating discs, ovoid blobs, or even square-ish blocks of different colors. And they can do so in less time than it takes a human to blink.

How cephalopods control the blooming of their colors has only recently been understood. Much of the mechanics were worked out in Roger Hanlon's lab. Nerves generate electrical impulses that transmit the information commanding the chromatophores to open and close. An arresting demonstration of how they work was created by University of Michigan Medical School neuroscientist Greg Gage and colleagues, founders of a company called Backyard Brains, which develops kits for students to explore neuroscience. They used their experiences in Hanlon's lab to create a video that literally set a cephalopod's chromatophores to music.

Using a suction electrode, the scientists connected an iPod Nano to the fins of a dead longfin squid, stimulating the nerves electrically. "An iPod plays music by converting digital music to small currents that it sends to tiny magnets in the earbuds," Gage explains. In this experiment, they replaced the ear buds with the fin nerves.

The song they chose to illustrate the principle was a platinum hit single: "Insane in the Brain" by Cypress Hill. The bass frequencies of the song,

A day octopus (*Octopus cyanea*) hides in the reef off the Hawaiian coastline.

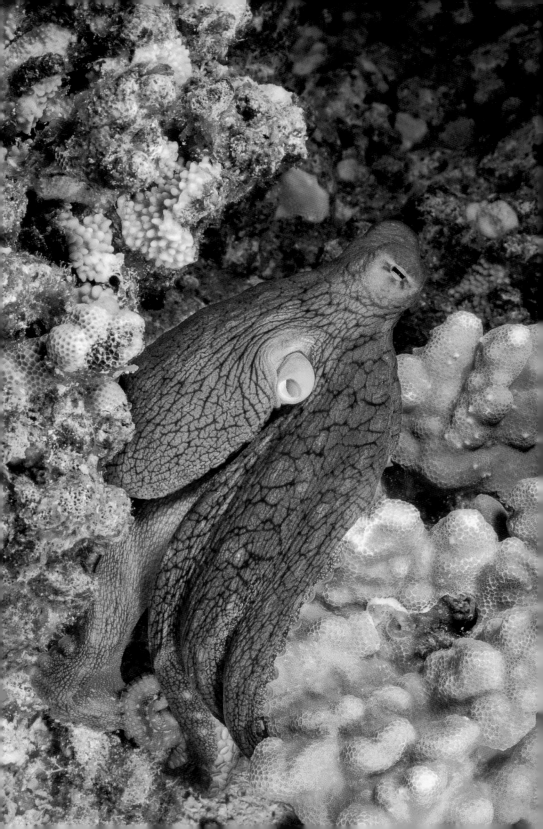

transmitted by the electrodes, were strong enough to fire the nerves that caused the muscles surrounding the chromatophores to contract. Using eight-fold magnification, one could see the brown, red, and yellow colors of the dead squid come alive, pulsing psychedelically to the bass notes of the hip-hop hit. The resulting video went viral. "An amazing collaboration between hood life and sea life," wrote one YouTube viewer. Gushed another fan, "This is the greatest thing I've ever seen in my life."

BENEATH THE CEPHALOPOD'S chromatophores lie even more mysterious organs: a shimmering layer of crystal-bearing cells called iridophores, nicknamed "bearers of rainbows." Roger Hanlon's lab has labored for years to understand how they work. These cells are colorless themselves, but like rainbows and soap bubbles, they reflect light at different wavelengths and can create the appearance of iridescent blues, glittery greens, and luminous pinks, silvers, and golds. Combined with the action of the chromatophores, the iridophores can create entirely new colors and patterns, as well as alter brightness and contrast.

But how are the iridophores controlled? For decades, scientists believed no nerves were involved. Researchers thought they might be activated by the release of the neurohormone acetylcholine, which in humans controls heart rate, breathing, and digestion, among other things. Or, they thought, perhaps chromatophores simply contracted or relaxed to reveal the lower layer of iridophores underneath.

Finally, after 20 years of research, Hanlon and his team found the answer. "At long last we have clean evidence that there are dedicated nerve fibers that turn on and tune the color and brightness of iridophores," Hanlon announced when the team's paper was published in the journal *Biological*

*Sciences* in 2012. By tracing a highly branched network of nerves in the longfin inshore squid, and stimulating them electrically, Hanlon's team was able to show how the color of each iridophore, as well as the speed of change, is—like the chromatophores—controlled by the animal's nervous system.

And beneath the iridophores, octopuses and cuttlefish possess yet a third layer of specialized cells called leucophores. (Squid do not have leucophores.) Leucophores appear elsewhere in the animal kingdom—polar bear fur is white, for example, because its leucophores scatter full-spectrum light. In a cephalopod, the leucophore layer provides the bright canvas upon which the animal paints its changeable skin-scapes. Because these cells also reflect light, like a mirror, they may further aid in color matching. This layer appears not to be controlled by nerves and muscles. But the texture of the octopus's skin and the shape and posture of its body certainly are—yet more remarkable techniques of camouflage.

Octopuses and cuttlefish change the texture of their skin thanks to spikes called papillae, which they can pop up like a fish raising a fin. In octopuses, novel groups of specialized muscles can erect hundreds of papillae inside of a second—and, using a motor nerve dedicated specifically to the job, these muscle groups can hold each papilla erect for up to an hour.

With such a toolkit of shape-shifting techniques, an octopus can look like almost anything. So how can scientists even tell which species they are studying?

It's not always easy.

FOLLOWING PAGES: An octopus releases an ink cloud as a defense mechanism. The ink comes out of the octopus's siphon, from which the creature can also jet water and release waste.

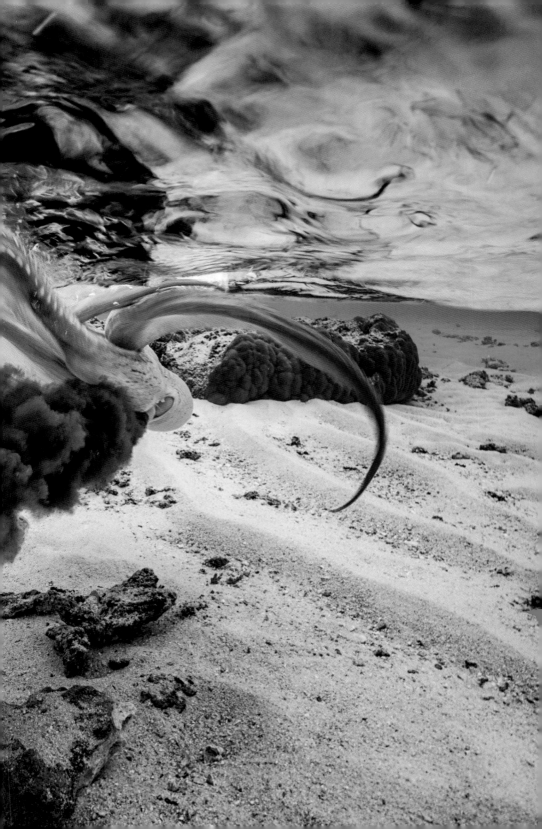

GROWING UP ON the tropical beach of Natal in Rio Norte, Brazil, Tatiana Leite discovered her deepest wish while still a child. She wanted a life that allowed her to "stay in the sea, surrounded by animals," she explains. So she was delighted, as an undergraduate at Universidade Federal do Rio Grande do Norte, when her biology professor asked her to capture and collect mollusks for the class. She chose to focus on octopuses—"so much more fun than shells," she says.

As a graduate student, she collected octopuses across oceanic islands for an oceanography course. Now she was asked to take measurements of the most familiar octopuses living along the reefs off Brazil's St. Peter and St. Paul Islands, the widely distributed and well-known *Octopus vulgaris*.

At first, the animals were hard to find. They hid in holes. They camouflaged themselves to look like the sand, and then, when traveling through the water, they often turned themselves blue-green, shimmering like the sun-sparkled sea. "I learned to look for the den, not the animal," she remembers—the den location often given away by neat piles of clam and crab shells, stacked like the empty plates from a room service meal left outside a hotel room door. Often the octopus was inside.

She got very good at this. But the job was breaking her heart. To measure the animals back at the lab, she had to kill them, and she hated that. And what's more, after she measured the octopuses, it was clear that something was off. Her measurements didn't match those for the common octopus.

"My professor said, 'You're doing everything wrong,'" Tatiana remembers. He suggested she change her method, that she freeze the corpses of the octopuses for 24 hours, then preserve them in formalin, before measuring. But that didn't change her results. Her animals consistently were squatter and more muscular than the species she was supposed to be seeing. Hers had thicker, shorter arms in proportion to the mantle and the head. Their beaks were shorter, with a squarer angle, than those of *Octopus vulgaris*.

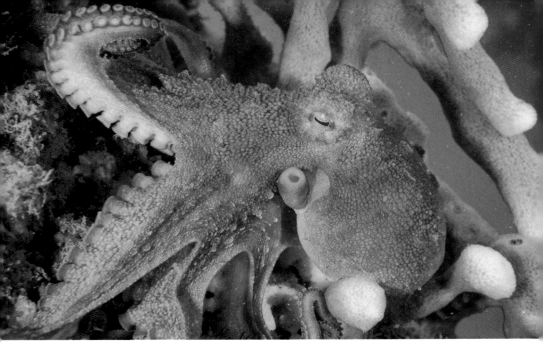

A common Sydney octopus (*Octopus tetricus*) hunts among
the sponges of Sydney Harbour, Australia.

She continued the project for two years. By then, having measured more
than 60 specimens, Leite was done with killing octopuses for science. "I
said, 'I can't continue my career like this,'" she says today. "'I have to find a
new framework for classifying them that isn't killing them. We need a new
way to do taxonomy, by studying living animals.'" She traveled to Spain,
where she continued her work by observing common octopuses living in
an aquarium. But there she saw a completely different creature from the
ones she had studied in Brazil. "When I saw the animal alive, I thought,
'How did people not see the difference? They are *not* the same!'"

The first thing she noticed was the difference in colors. The shimmering
blue-green she often saw in swimming octopuses in Brazil was almost never
exhibited in the *vulgaris* species in the Spanish aquarium. Furthermore,
the common octopus is far more likely to hunt at night, concealing itself
with red and dark colors while traveling. But the Brazilian octopuses she
knew so well were most active by day.

Genetic analysis confirmed what she suspected. Leite had discovered an entirely new species, now known as the island octopus, *Octopus insularis*. It had been there all along, misidentified as *vulgaris*. Her surveys now indicate it is the dominant species of octopus in northwestern Brazil. And, like the common octopus, the island octopus may be widespread. Specimens have been identified as far north as Bermuda. And a newly published paper suggests the species may also be found as far away as Africa.

Videotapes and photos show the island octopus exhibits several combinations of color and pattern new to science. When the island octopus wants to hide the undersurface of its arms, it turns the spaces between the suckers a unique spackled reddish brown. To startle a predator, members of many octopus species make a ring around their eyes to seem like a much larger animal—usually a dark ring. But the island octopus surrounds its eyes with a huge white circle or, sometimes, a blue-green ring. In fact, Leite reports, the animal Hanlon filmed in the Caribbean transforming itself from a clump to algae was not a common octopus after all, but the newly named *Octopus insularis.*

Leite believes that when octopuses are studied carefully in the wild, each species may reveal a number of unique visual displays. The day octopus (*Octopus cyanea*) can create a distinctive spot, resembling an eye, at the base of each third arm; a new species of large octopus, previously mistaken for the giant Pacific octopus, was identified by noting an extra "branch" on the raised papillae over its eyes.

With students and colleagues, Leite is developing a key that can serve to help identify octopus species in the wild—while they are living, without killing the animals. "The common colors and displays can help us distinguish the species," she says. She and her colleagues are already using the method with great success. Since discovering the island octopus, she has described other new species, including a half-ounce (14 g) pygmy species (*Paroctopus cthulu*) with five different body patterns, reported as recently as 2021. She

is now working on the description of five new species of cephalopods, including squid and octopuses. There could be dozens, or even hundreds, of new species yet unidentified or mistaken for species already known.

Ironically, while the octopuses are fabricating their intricate disguises, they may be revealing to us their true species identities. And they're telling us more. The living canvas of octopuses' electric skin conveys something crucially important about how they live in their habitats.

THE VIDEO STILL EVOKES GASPS, then laughter: A coconut octopus (*Amphioctopus marginatus*), its skin mottled with red, orange, brown, and yellow, tucks its head and mantle into a ball, wraps six of its arms around itself, and uses its other two arms to stride briskly along the pebbly sea bottom. The speed of its stride evokes the "William Tell Overture."

The arms seem to angle just where you'd expect an ankle to be, and the forward tips of the octopus's walking limbs seem to stick out straight like overly large shoes. The animal looks like a cartoon of an octopus cast as someone self-important, a big-bellied person in a hurry. Christine Huffard, now a senior research specialist at Monterey Bay Aquarium Research Institute, reports that a number of people watch her video of the bipedal octopus and conclude, "They're taking over the world now."

She first observed this strange behavior when she was still a graduate student in 2000. She was assisting a documentary film crew, providing scientific input as they shot footage for a segment on octopuses off the Indonesian island of Sulawesi. The late cinematographer Bob Cranston captured

FOLLOWING PAGES: While most octopuses hunt at night, the day octopus uses its ability to change colors as camouflage and hunts in the sunlight.

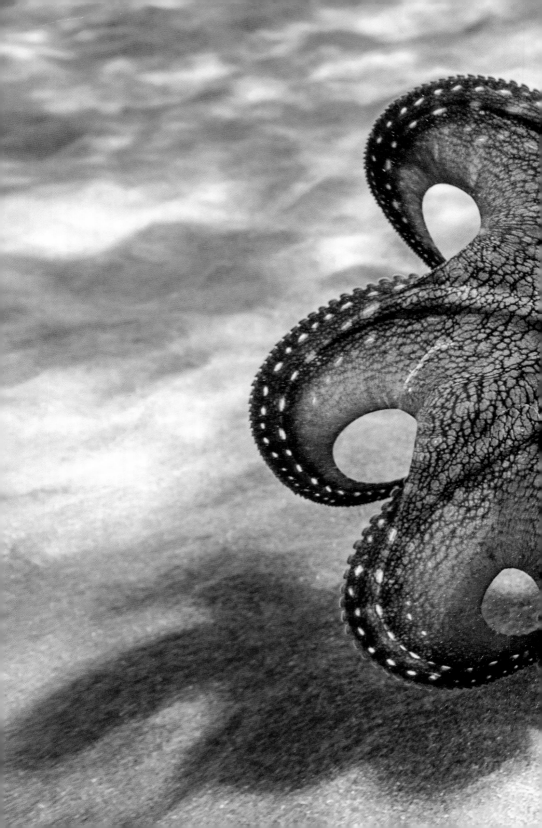

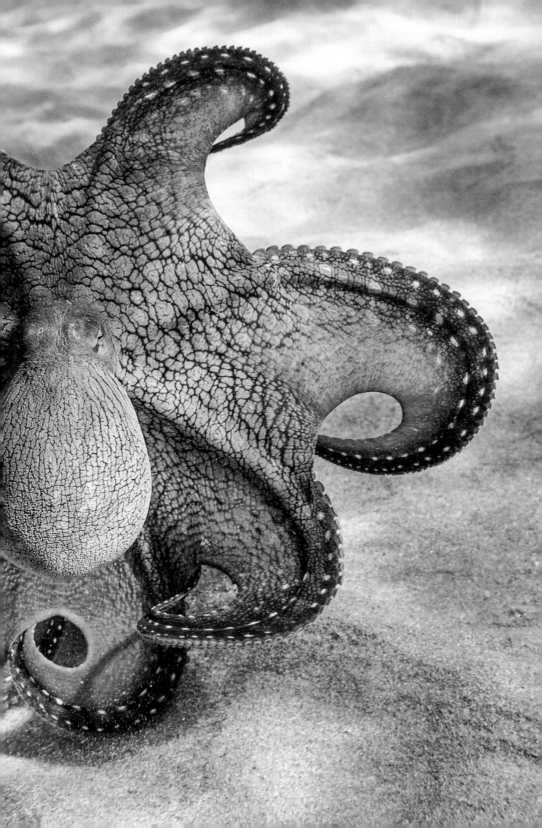

images of the apple-size, short-armed coconut, or veined, octopus walking on two legs along the bottom. "It was hysterical to see," she remembers. She laughed so hard, she flooded her dive mask.

Three years later, while working on her graduate thesis, she witnessed the same bipedal gait—in a different species 1,600 miles (2,575 km) away.

She'd gone to visit her thesis advisor, Roy Caldwell, who worked at Lizard Island along Australia's Great Barrier Reef. She'd devoted years to studying the tiny algae octopus (*Abdopus aculeatus*) with a mantle about the size of a walnut and arms that stretch about finger-length at rest. It's named for its ability to sculpt its papillae into a tangle of frizzy fuzz that looks just like algae. She had conducted her fieldwork in Indonesia but now had a chance to observe the subject of her thesis in a new place.

She'd captured an algae octopus along the reef and was keeping it in a large tank at her advisor's lab. And what she saw there was, if anything, even more bizarre than the walking coconut octopus. Instead of wrapping its arms around its body, the newly captured algae octopus held its two front frizzy-looking arms aloft, while another two sets of arms shot akimbo—each one ending in an irrepressible curlicue, like Shirley Temple's curls on a humid day. Meanwhile, stranger still, its two back arms scurried along the bottom of the tank like legs. In the wild ocean, it would look like a piece of broken-off algae tumbling along the bottom.

"I'd already spent thousands of hours in the water studying this animal," she says, "but I never saw it do this before."

She was so intrigued that she filmed the behavior to show it to colleagues. "I thought it was cool," she relates, "and wondered whether anything else underwater walked bipedally." But no one else at the research station knew of other examples. And nobody thought it was particularly exciting. "So," Huffard says, "I didn't take it further."

But later, she was working on a paper on the different body postures of octopuses. She included a drawing of the coconut octopus walking and

showed it to colleague Sheila Patek—then a postdoc in Huffard's lab whose studies of biomechanics would later lead to a Guggenheim fellowship and an appointment at Duke. Patek pointed out the significance of the discovery. "Octopuses," Huffard realized, "are the only animals who can walk bipedally without a rigid skeleton."

When Huffard showed Bob Cranston's film of the walking coconut octopus to Robert Full, a professor of integrative biology at the University of California, Berkeley, he told her he was "blown away." Together they worked on an analysis, and their paper on the walking octopus was published in the journal *Science*.

Bipedalism itself is not, of course, all that unusual. We're not the only creatures who walk on two legs. Apes occasionally do it, and so do kangaroos, some lizards, and certain rodents. Birds walk bipedally. Even cockroaches rise up on two legs when the situation demands. (That's when they run at top speed—otherwise, their four other legs get in the way.) But walking on two limbs entails moving in a manner that no soft-bodied invertebrate should be able to do. To move like this, it was thought you needed a skeleton: either an internal one like ours, or an external one like those encasing the bodies of insects and crabs.

A close examination of walking octopuses shows that these animals fool us again and again. Watching her videos, Huffard saw they are not striding exactly as a person does: They are using the outer halves of their two back arms to alternately lay down one sucker edge after another and rolling it along the ground—like a conveyor belt or the treads of a tank. And they are not moving forward, as a person does walking. They are actually moving *backward*.

Octopuses can trundle along like this at an impressive clip. Huffard clocked one coconut octopus traveling at five and a half inches (14 cm) per second—not bad for an animal whose head is the size of a walnut and who stands only six inches (15 cm) tall. That's a third of a mile an hour (0.5 km/h)—faster than they move using their more usual gait, often called a crawl, with more limbs

involved. Of course, they could shoot through the sea far faster using their jet propulsion with the funnel at the side of the head—but that movement would give them away. They would no longer resemble a rolling coconut or a clump of tumbling algae. Walking on two limbs, Huffard explains, "allows octopuses to move quickly without giving up their primary defense"—their camouflage. And this skill of bipedal walking might be more widespread among octopus species than previously thought. Leite and a colleague have since seen juveniles of two other species walking in a similar way.

How do octopuses achieve this unusual gait? "Instead of relying on bones for support," she explains, "octopuses rely on muscle." But their muscles are more like our tongues: supported not by bones, but by fluid inside them. "Octopuses have bands of muscles arranged longitudinally, circularly, and in a helix," Huffard observes. "By all these muscles squeezing against each other, opposing muscles can create a pseudo-joint."

Robert Full predicted that Huffard's findings "could usher in a new frontier" of engineering, inspiring the creation of soft-bodied robots. Robots made of pliable, elastic materials could work in settings that would defeat rigid machines, such as underwater, in outer space, and inside human bodies. And indeed, in a project that commenced in Italy four years after Huffard's paper came out, soft robots modeled on octopuses were developed. Today, proto-types modeled on the octopus can transform their shapes and sizes to twist, stretch, turn, and grasp with enough dexterity and sensitivity to handle objects as delicate as a ripe tomato. Though the field is still in its infancy, the market for soft robots is projected to reach a value of $3.14 billion by 2027.

But does the octopus, like a robot, adjust its gait, its color, its shape with-out thinking? Huffard, now considered a world expert on the algae octopus, and the discoverer of half a dozen new octopus species, doesn't know. Many of the octopus's moves may be purely instinctual. Baby octopuses begin using their chromatophores the instant they hatch. "There's a lot they can do as hatchlings," she notes. But humans walk and run without invoking

conscious management of each stride. "You can learn to run faster," she says, "using your knowledge of running." Perhaps octopuses do, too.

And then, there's blushing. Huffard knows a lot about that firsthand; she blushes a lot. ("Maybe I'm part octopus," she muses.) It's a completely involuntary response. But when it occurs, it's a window into a complex emotional state as it's experienced by an intelligent creature. Could this be so, too, for octopuses?

IN JERVIS BAY off the south coast of New South Wales, Australia, a darkening shape erupts from a bed of scallop shells. Like a silk scarf floating up from the water, a gloomy octopus (*Octopus tetricus*) flows from its den.

Underwater video cameras, anchored by weights, record the action. The octopus has emerged in order to meet another, smaller one, crawling toward him. The first octopus stands tall—mantle elevated and rigid, arms on tiptoe—and flushes its skin an ominous black. He's big, he's intimidating, and he's not friendly toward the smaller newcomer. The big, dark octopus looks remarkably like the helmet on Darth Vader's head. As the two animals rush toward each other, the big octopus casts the webbing between its arms over the intruder like a net. The smaller octopus struggles, shrinks, melts. In a flash, the intruder flees, shooting away as white as a ghost.

At times, even as they exhibit their most alien superpower, cephalopod behavior seems uncannily like our own. They even seem to exceed us in their social finesse. A number of octopus species, as well as other cephalopods, can display a threatening color toward potential predators on one side of their bodies, while courting a potential mate with a conciliatory hue on the other. When Roger Hanlon lectures, he likes to show video of a male cuttlefish employing this complex dual signaling. "I would argue," Hanlon

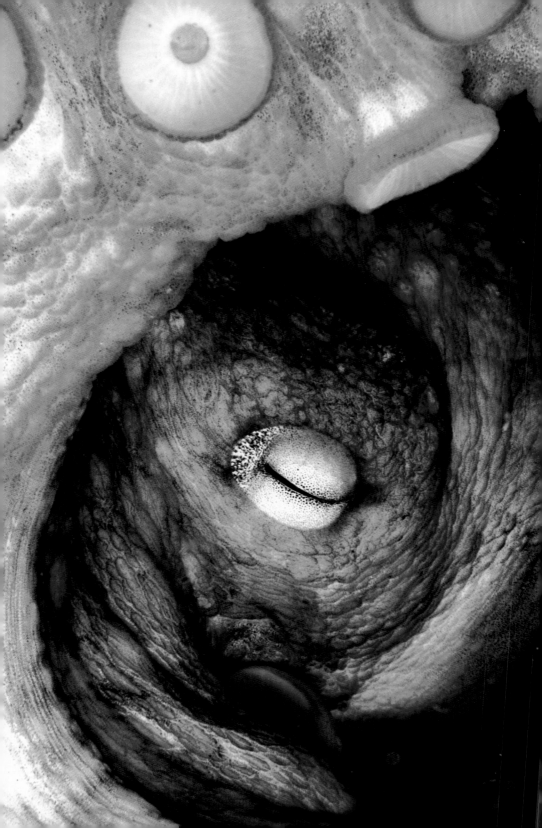

says, "that dynamic camouflage is a form of intelligence." But in his lectures, Hanlon sometimes puts "intelligence" in air quotes. Octopus ways of knowing are in many ways startlingly different from our own, and they arose from utterly different evolutionary pressures.

Their eyes, for instance, look highly similar to those of humans. But they're located where our ears are. They have little depth perception. They see polarized light, invisible to us. They can see at night. They can see at deep sea depths. And, incredibly for animals who can so perfectly match the colors of the world around them, octopus eyes are color-blind.

The light-sensitive cells in the octopus retina contain only one pigment. Ours have three; dogs, two. Researchers believe that octopuses must use entirely different systems from our own to perceive and match the colors of their complex world. Octopuses' electric skin, along with the chromatophores and the nerves erecting the papilla, contain proteins normally found in eyes. In 2015, evolutionary biologists at the University of California, Santa Barbara, working with patches of skin harvested from California two-spot octopuses (*Octopus bimaculoides*), reported that the skin is sensitive to light and can detect changes in brightness. In other words, octopuses may be able to feel light—or see with their skin.

Researchers from disciplines as varied as psychology, ethology, and marine ecology are now exploring questions scientists never dared pose before: Do octopuses experience emotions as we do? What do they remember? How do they learn? Can they imagine the future? What does it feel like to be an octopus? One thing octopuses have shown: To find the answers to these and other questions, as Alex Schnell has discovered, "You have to think outside the box."

---

Scientists suspect the common octopus's flat pupil creates chromatic aberration, an effect that makes things blurry for human eyes but seems to help the octopus navigate its world.

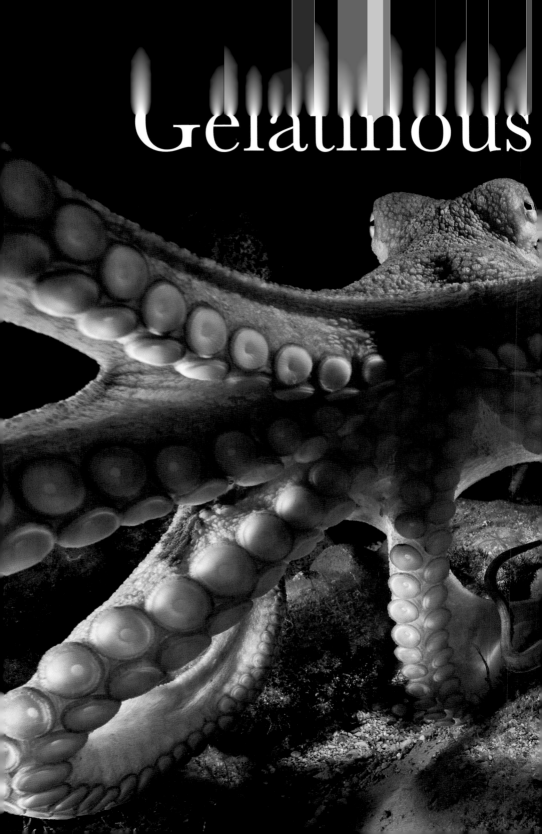

# Gelatinous

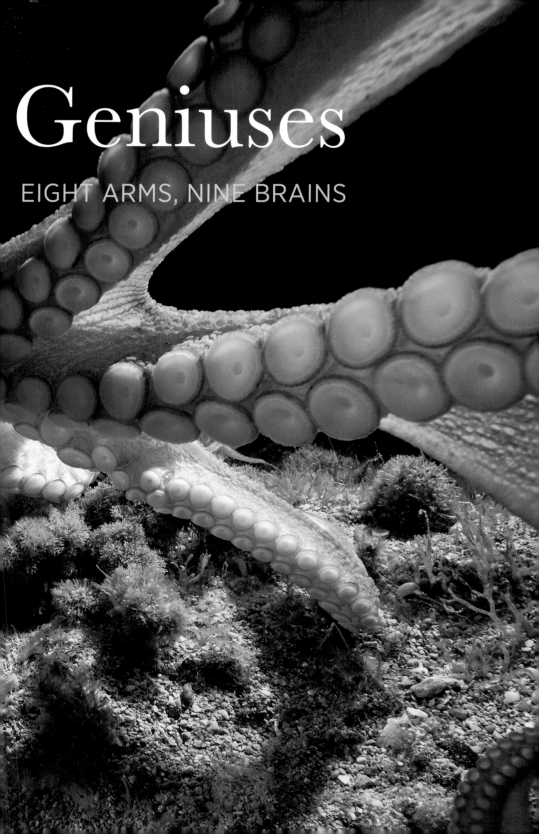

# Geniuses

## EIGHT ARMS, NINE BRAINS

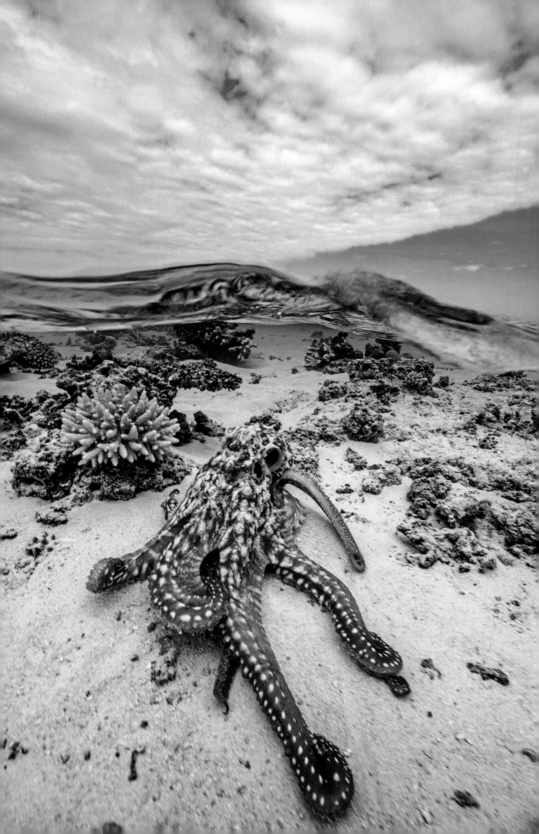

hen she walked through the door to the lab that morning, Alex Schnell was immediately confronted with an emergency.

There, on the concrete floor, was a foot-long octopus. This was pretty early in her career studying cephalopods, but she already understood quite well that this was not a good place for an octopus. They breathe water, not air. Their skin dries out. A small octopus can typically survive only 20 or 30 minutes out of water. And picking up a slithery, slimy creature, equipped with eight strong arms that are famous for resisting arrest, is not a very easy job for a human. She remembers being impressed with the animal's agility, despite him being out of the water. She grabbed a plastic bucket and gently picked him up off the floor by the mantle, placed him inside, then filled the bucket with water from the closest saltwater hose.

Of course, the question was, how had he gotten out? All 20 of the common Sydney octopuses (*Octopus tetricus*) in her lab were housed in heavy-duty plastic dive storage containers weighted down with bricks. Carrying the escapee in the bucket, she searched for the empty tank. When she found it, the lid was sealed tight. "I was absolutely flabbergasted," she says. A cable tie holding a mesh covering on the outflow pipe had come off. The octopus had squeezed through an opening the size of a cherry. Once having gained his freedom, he was still exploring—and even in the bucket, he didn't stop. The octopus "kept reaching out a tentative arm to touch my fingers as I

An octopus luxuriates in the shallows of the Indian Ocean.

<small>PREVIOUS PAGES:</small> This common octopus, named Angelica Evangelista by the photographer, showed a particular interest in the camera equipment.

carried the bucket around looking for his container," says Schnell. Ever after, that octopus has gone by the name Houdini.

It was just another day in Alex Schnell's study, where she was investigating aspects of octopuses' reported ability to learn through observation. But the octopuses outsmarted the researcher at every turn.

"With octopuses," says Jim Cosgrove, retired from the Royal British Columbia Museum and an expert on the giant Pacific octopus, "these animals are so intelligent that I used to tell my students, 'Sometimes you are working on your master's degree, but the octopus is working on its Ph.D.'"

At the Octopus Lab at Vermont's Middlebury College, pre-vet student Frances Warburton was having similar problems. She and her fellow students were working with 30 individual octopuses of two different species, the California two-spot (*Octopus bimaculoides*) and the Caribbean pygmy octopus (*Octopus joubini*). She was trying to move one from the home tank to test his performance in a T-shaped maze when, to her alarm, the octopus "used the net as a trampoline" to launch onto the floor. Warburton was forced to chase the octopus as he scampered ("like a cat!") around the room.

The students had weighted down the lids to the animals' tanks to keep them shut. But the octopuses still got out. They'd ooze their gelatinous bodies through the tiniest openings. Even in a 400-gallon (1,514 L) tank, divided into individual apartments with plexiglass walls, the octopuses could slip through nearly invisible gaps to get into adjoining apartments—and then proceed to eat each other. When Warburton would put an octopus into a maze, half the time, instead of navigating it, the creature would wedge itself into a corner and hide. That's what happened during Warburton's thesis presentation, before her professors and advisors. But first, the octopus shot a stream of freezing cold salt water from its jet at Warburton, soaking her best suit.

Warburton loved working with the animals at the octopus lab (which has since closed with the retirement of its founding faculty professor), but "every day" spent there, she remembers, "was a disaster."

Aquarists' lore is studded with tales of octopuses behaving badly. In Santa Monica, an eight-inch (20 cm) California two-spot octopus, apparently experimenting with a valve in her tank, managed to flood the aquarium's offices with hundreds of gallons of seawater, ruining the newly installed floors. In Coburg, Germany, a common octopus named Otto shorted out the entire electrical system of the Sea Star Aquarium three days in a row. An aquarist posted to spy overnight discovered how Otto did it: The octopus climbed to the roof of his tank and aimed water, squirted from his jet, at a 2,000-watt spotlight overhead, dousing it until the light was extinguished. (Otto also annoyed his crab tankmates by juggling them, and once damaged the glass in his own tank by hurling rocks at it.) At the Seattle Aquarium, keepers named one female giant Pacific octopus Lucretia McEvil because she routinely dismantled everything in her tank, including the filter.

Not for nothing did Schnell name her runaway octopus Houdini. They are escape artists. An employee of the Marine Biology and Ecology Research Centre in Plymouth, England, L. R. Brightwell, was once mounting the stairs at the institution early one morning when to his surprise he encountered an octopus crawling down them. Brightwell was on a trawler expedition in the English Channel when a fisherman caught a small octopus and unwisely left it on deck. Two hours later, it was found in a cabin, ensconced in a teapot. And in spring 2016, a New Zealand octopus (*Macroctopus maorum*) named Inky made headlines when the lid to his tank was left ajar one night and he crawled out. In the morning, a slime trail bore witness to his journey. After pouring his pudding-like, football-size body over the lip of the tank, he had slithered to the floor, crawled eight feet (2.4 m) across the floor, squeezed past a drain—and slid through a 164-foot (50 m) drainpipe, which led directly to Hawkes Bay, where he had been captured two years before.

Inky may not have realized his breakout would take him home. But other octopus escapees seemed to have a goal in mind. Another account, dating back to 1873, tells how the stock of lumpfish at the U.K.'s Brighton Aquarium

began to slowly diminish for no apparent reason. Then one morning an employee found an octopus in the lumpfish tank. He concluded the animal had been routinely escaping its own tank, eating its neighbors, and then returning home before the humans came back in the morning.

The intervening centuries have brought many similar accounts of octopus breakouts, apparently executed specifically to raid other tanks. In the 1980s, a giant Pacific octopus at Boston's New England Aquarium was discovered eating some special flounder kept for research in a tank three feet (1 m) away from his own. In 2015, when aquarists at the Bermuda Aquarium, Museum and Zoo began finding empty crab carapaces where live crabs should have been, they discovered the culprit was the common octopus in the tank next door.

All this havoc suggests advanced, if not diabolical, intelligence—which researchers are eager to document, especially in a spineless creature more closely related to clams than to people. But the very attributes that make octopuses' apparent brain power so intriguing to investigate also make it extremely difficult for researchers to do so.

Collaborating with Peter Godfrey-Smith, an Australian philosopher of science then at Harvard, Schnell was trying to document the ways octopuses figure out their world. Octopuses are famously adept at unscrewing jars and opening boxes, especially if there is food inside. Do they learn solely from trial and error? From sudden insight? Or, like many primates, birds, rats, and even bumblebees, are they capable of learning by watching others?

To find out, Schnell placed one group of animals in individual fish tanks in front of a high-definition TV screen and treated them to a video of a human hand opening a jar with a tasty crab claw inside. Another group simply saw a video of a claw in a jar. A third group watched a video of a rock. The plan was to see which group learned how to open a jar first. What would the octopuses do?

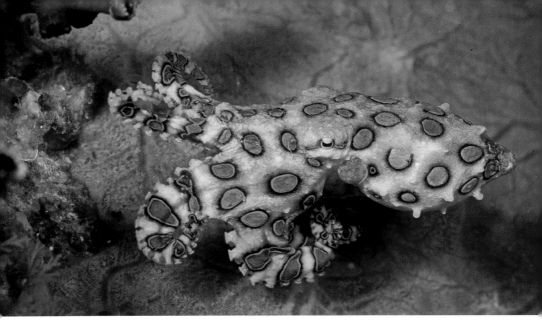

The highly toxic blue-ringed octopus (*Hapalochlaena lunulate*) explores a reef off the coast of Indonesia.

They would continue to confound the researcher.

"Some were willing to cooperate," Schnell relates bemusedly, "but others refused." It's no surprise that their responses were not uniform. Octopuses are famously individual, often earning them colorful names at aquariums. As well as Lucretia McEvil, the Seattle Aquarium also hosted a giant Pacific called Leisure Suit Larry—so named because, as one keeper explained, "his arms were always all over you." Then there was Emily Dickinson, of the same species, who was so shy she never came out from behind the filter, so the staff had to release her back to Puget Sound.

Nor were their responses predictable. Like people, octopuses can be moody, as Schnell discovered in her experiments. "Some were willing to participate on one day and would not the next," she says. "It was hard to get definitive data."

So, for a new round of experiments, she figured, "Let's try an animal that isn't going to make me lose my hair!" She switched to working with octopuses' cephalopod relatives (and, in some cases, their oceanic neighbors),

the giant Australian cuttlefish (*Sepia apama*). With expressive, W-shaped eye pupils, they share with octopuses the ability to change color and shape, but their eight relatively short arms and two long tentacles do not have the same dexterity as those of octopuses, so they are less apt to breach their tanks. And while cuttlefish, too, have individual personalities, they're reportedly not as temperamental as octopuses.

Next came the tough part. Designing tests to reveal the intelligence of any animal species is daunting. Researchers put chimps in a lab with pegs and various holes, and declared their charges brilliant when they solved the puzzle. Orangutans wouldn't even try. As primatologist Biruté Galdikas put it, "They simply weren't interested." In other primate experiments, researchers originally concluded gorillas lacked self-awareness because they didn't recognize their own reflection. Turns out, though, there was another explanation: To stare into the eyes of another gorilla is a threat, so gorillas in captivity purposely avert their eyes from mirrors. (On a similar note, Canadian researcher Cosgrove, working with a film crew, once tried a mirror test with giant Pacifics in the wild. He had captured several in mesh bags and planned to release them near a 6-foot [1.8 m] square of shiny stainless steel propped up on the ocean floor. "Would it look and think it was another octopus? Would it recognize its own reflection?" he wondered. "The answer is, none of that happened." Some of the terrified octopuses jetted off—understandably eager to get as far away from their captors as fast as possible. Several crawled right past the square without a look. Only one seemed to notice the shiny object. "It saw itself as a motion," Cosgrove recalls, "but did not recognize itself or even the fact that it was looking at a reflection.")

Schnell realized that to test the intelligence of a creature so different from us as an octopus, "you've got to come up with an elegant design. One that's ecologically relevant"—that is, devising a problem similar to one that wild animals would naturally want to solve—"but without copious amounts of training and so many controls that the results aren't clear."

With this in mind, Schnell devised some new tests to investigate cephalopod smarts with her cuttlefish. What she discovered blew people's minds—and changed the way we think about thinking.

HOW DO YOU MEASURE the mind of a mollusk?

The very thought that mollusks might have minds is a relatively new concept. Though octopuses are mollusks, too, this large phylum's most familiar members are shelled creatures like clams, slugs, oysters, and snails—none of which are credited with much in the way of brainpower. Many mollusks, such as clams and oysters, lack a brain entirely.

And if you were looking inside an octopus's head, you might not recognize the brain at all. Even a carefully drawn diagram of an octopus brain could be easily mistaken for a model of a Rube Goldberg mechanical device or a schematic of some flower from Mars. It looks nothing like our own. Our brain looks like a walnut in its shell—our skull. An octopus has no skull, and its brain is shaped like a ring wrapped around its throat. (In fact, if they bite off more than they can chew, they can get brain damage from trying to swallow the bolus.) Our brains have five distinct lobes, including the insula, located in a deep fissure called the lateral sulcus, each associated with different functions. Octopus brains may have 50 to 70 lobes—depending on the species and which scientist is counting them.

The human nervous system is made up of 86 billion neurons—the cells responsible for receiving and processing sensory input from the world—and most of them are in our brains. But for an octopus, the brain is the

FOLLOWING PAGES: An octopus lurks among a group of brittle stars, a relative of sea stars, off the California coast.

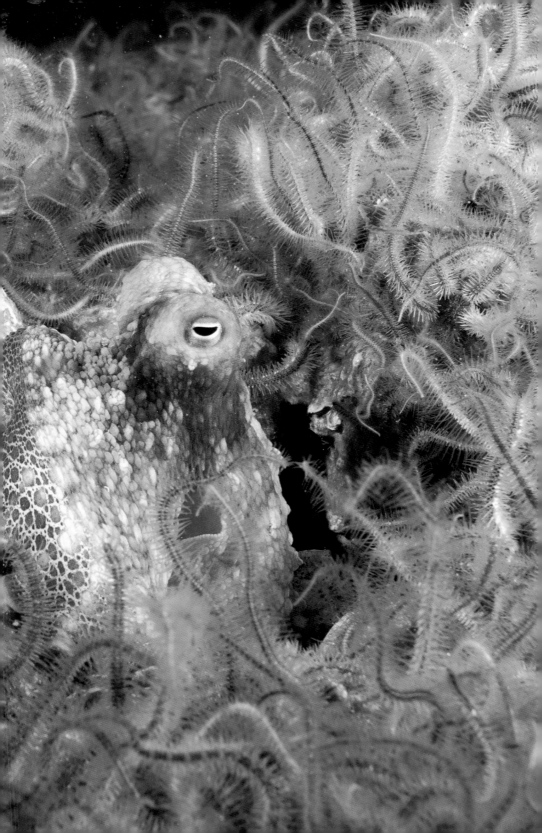

smallest component of the nervous system. As many as four-fifths of its neurons—perhaps 350 million of them—are in its arms.

Each separate arm, writes psychologist Frank Grasso, who directs the Biomimetic and Cognitive Robotics Lab at Brooklyn College, possesses what amounts to "the brain of a living organism." Each one of the eight arms possesses its own brainy processing center, capable of handling large amounts of information. And under certain circumstances, each arm can function perfectly well without input from the brain in the octopus's head. Even when detached from the body—by a predator's jaws, or by the scalpel of a wicked researcher—an octopus arm can go off and *do* things.

A detached octopus arm can even capture prey. Of course, by that time, the arm might have journeyed far from the mouth and digestive system that could nourish it—or ingest the prey—were it attached. Happily, though, an octopus can regrow a missing arm. And unlike lizards, which can generate only a decent semblance of a former tail, an octopus can grow a perfect replica of the old arm—even when a male loses its specialized third right arm, which lacks suckers at the tip but has the special ability to place a sperm packet inside a female.

The octopus's unusual nervous system raises an intriguing prospect. Perhaps, as New Zealand philosopher Sidney Carls-Diamante suggests in a 2022 article in *Frontiers in Systems Neuroscience,* "octopus arms proffer the possibility of a radically different form of consciousness from what we are currently familiar with." What if octopuses' arms have "their own respective conscious fields"—consciousness that consists of multiple "selves" that the octopus must somehow integrate into a single body? Could octopus arms have different personalities—some shy arms and some bold arms?

It's no wonder investigating octopus intelligence can be as thorny as their papillated skin.

"It's difficult in science," says Schnell. "People who study animal behavior tend to stay away from consciousness and sentience, because it's so con-

tentious." Some scientists and philosophers question whether consciousness exists—even in humans. "It's difficult to measure. It's difficult to even define," says Schnell. And, as she points out, speaking of the octopuses she studies, "These creatures can't communicate with us verbally." So how to design a test to discover what someone so different from us thinks?

Concepts like consciousness and sentience are as slippery as a loose octopus—even when applied to humans. One of the landmark experiments in human psychology was designed to investigate the mental lives of others who can't always tell us clearly what they understand about the world: preschool children. Known as the Stanford marshmallow test, it was developed in 1972 to measure preschoolers' ability to delay gratification. Kids were asked to pick the treat they liked better—a pretzel or a marshmallow—and given a choice: They could eat one now, or they could wait and get two later. In follow-up studies years after, the children who had waited for two treats achieved higher SAT scores than those who had succumbed to temptation. While other follow-up studies showed the marshmallow test wasn't a strong predictor of adult behavior, the ability to forego instant gratification is still thought to be an important step for humans in making increasingly complex decisions.

Cephalopods don't eat marshmallows, take the SATs, or follow verbal instructions. But Schnell realized that if she could adapt the marshmallow test and other experiments testing human memory and decision-making to cuttlefish tastes and talents, she might be able to create a lens through which to view how these mollusks make choices. Do they draw on past experience? Can they anticipate the future?

She took a cue from one of her mentors, University of Cambridge professor Nicola Clayton. Clayton's groundbreaking experiments with captive jays clearly proved that, in some ways, these birds' memories and problem-solving abilities rival those of chimpanzees and human children. But, of course, Schnell had to devise experiments that would cater to creatures who prefer

mealworms to marshmallows, who use beaks and feet instead of hands and fingers, and who answer our questions with behavior instead of words.

To even begin to get answers, Schnell realized she would have to train her cuttlefish. "It's an arduous process," she said. To train them, she needed a good reward. What treat might her subjects prefer? The overwhelming favorite was live glass shrimp; previously frozen king prawn were less exciting.

Then she had to train the cuttlefish to associate each food with a different symbol. In the resulting experiment, Schnell presents each participating cuttlefish with two underwater chambers. One is marked with a circle. When she drops a frozen prawn into that chamber, a plexiglass door immediately opens, allowing the cuttlefish to seize the food with its two long feeding tentacles. The other chamber is marked with a triangle. The cuttlefish can watch through the plexiglass door as Schnell drops the preferred snack—the live shrimp—into that chamber. Initially, the cuttlefish attacks the closed door with its feeding tentacles, until it realizes its efforts are for naught—until the door opens. Over the course of several days, the cuttlefish learns that the door marked with the triangle leads to the preferred food, but it has to wait to get it.

Next, the cuttlefish is presented with a new learning challenge. Two underwater chambers are offered at once—one with live prey, one with a frozen prawn. But once the cuttlefish eats the food in one chamber, the food in the other is removed. The cuttlefish learns it has to choose one or the other. It cannot have both.

Finally, the chambers are once again marked with a circle and a triangle, denoting the two different treats. If the cuttlefish lunges for the chamber marked with a circle, it will get to eat the prawn immediately—but the delicious glass shrimp will be taken away. If it waits for the treat in the chamber marked with a triangle, eventually the cuttlefish will be rewarded with the glass shrimp.

"It's a difficult decision, fraught with temptation," Schnell notes with empathy. And she can see the cuttlefish's mental struggle. Sometimes, she notes, they seem to purposely aim their distinctive eyes away from the tempting prawn, waiting for the delicious shrimp. Children in the marsh-mallow test employed the same tactic. They sometimes covered their eyes with their hands, or played with a nearby toy, to distract themselves long enough to wait for the better reward.

Schnell's cuttlefish were able to wait out delays between 50 and 130 seconds to get a preferred treat. And because of the experiment's careful design, it's clear the cuttlefish learned more than simply to wait before eating. The animals were able to associate specific outcomes with special symbols in their minds. They remembered their training. They knew that the triangle indicated their favorite food, and so even without seeing the glass shrimp behind that door, they knew the preferred treat would appear in that chamber and not the other. And they could use these lessons to guide their behavior in the present. In this remarkable experiment, invertebrates related to brain-less clams and oysters demonstrated, for the first time, memory, learning,

A cuttlefish in Alex Schnell's experiment awaits access to a prawn.

and self-control worthy of animals renowned for their smarts. In these respects, the cephalopods were on a par with crows, parrots, and chimps.

But like humans, cuttlefish are individuals. Not all are able to resist temptation. "You do get the impatient ones," Schnell says. "There was one young cuttlefish who would squirt me with her siphon repeatedly until I would come over to feed her. They have so much character."

BACK ON THE INDONESIAN SEAFLOOR, coconut octopuses are acting peculiarly like people as well. This time, not only are they strutting along the ocean bottom, but they are also carrying around some bulky luggage.

Looking like an overloaded traveler at an airport, an octopus carrying half a coconut shell grapples with its heavy and unwieldy load. Its burden is actually larger than its body. To carry it, the animal must arrange the curve of the shell convex side down beneath its apple-size body. It grips the prize with the tips of several six-inch-long (15 cm) arms, as it tiptoes awkwardly along on its remaining limbs, waddling backward along the muddy sea bottom.

Julian Finn of the Museum of Victoria in Melbourne, Australia, had been looking for a different species of octopus when he noticed half of a broken coconut shell lying on the seafloor. Then he saw it move. A coconut octopus emerged from beneath the curved dome of the shell. Finn stopped to watch, and what happened next was as revelatory as it was hilarious: The octopus flipped the shell over, jumped on top of it, and, holding its ungainly prize with several arms, hurriedly waddled away.

"I followed it for some time," says the scientist. What it did next astonished him. After some minutes of lugging its ungainly burden, the octopus located another half of a coconut shell sunken in the mud and grabbed it.

The animal fitted its body into the welcoming curve of the first shell and then, using its suckers to pull the second shell toward the first, created a spherical safe spot. As Finn puts it, the octopus "enclosed itself in a sort of protective armor."

In other words: The octopus was making and using a tool.

Until 1960, when Jane Goodall reported seeing chimps bending twigs to fish termites out of their nest, tool use was considered the Rubicon separating people from all other animals. Tool use was, in some circles, one of the defining characteristics of humankind, considered the crowning achievement of high intelligence.

But soon enough, ethologists reported tool use among other animals: Dolphins carry marine sponges to stir ocean bottom sand; orangutans fashion whistles from twigs to scare off predators. Crows use twigs to spear hidden grubs. Elephants break off branches to scratch themselves, swat flies, and even to cap small waterholes so they don't evaporate.

Researchers theorized that tool use, and high intelligence in general, is sculpted by the demands of highly social, long-lived species like these. Most of the animals who spring to mind as smartest are those who, like us, must navigate the challenges of complex social groups. Elephants live in female-bonded herds numbering as many as a hundred. Like us, they enjoy protracted childhoods, with the opportunity to learn from a nurturing parent, as well as aunts and older nieces and nephews. Young orangutans are still nursing from their mothers at age eight. Like us, these smart species enjoy remarkably long lives. The world's oldest captive orangutan, named Nonja, died at age 55. In captivity, a crow can live to 30; a lucky dolphin might reach 60, and an African elephant, 70. The challenge of competing with and cooperating with so many relatives, friends, and enemies over the course of a long lifetime was thought to have driven the evolution of big, complex brains.

But what about octopuses? As Schnell points out, "They are almost the exact opposite. They live fast and die young." One of the longest-lived, the

giant Pacific, can survive only three and a half to five years. Octopus mothers care for their eggs, but not their young. They may use their last breaths to blow their newly emerged hatchlings out of the den and into the open ocean. And most of the literature on wild octopuses insists they are generally loners. How, then, did they evolve their exceptional intelligence?

"When you consider the body of an octopus," Schnell says, "they are as alien and different as you can imagine from ourselves. But what I want to know is—does this mean our minds are equally different?" Schnell examines this enigma by comparing the cognitive powers of chimps and crows with those of cephalopods.

Her conclusion: Octopuses evolved their exceptional smarts by an entirely different route than vertebrates. Instead of being sculpted by the demands of long lives and group living, their intelligence was launched by the loss of the ancestral shell.

In octopus evolution, losing the shell was a trade-off. Without the armor that protected their molluscan kin, the ancestors of octopuses were exposed to a plethora of new predators. Now they faced new challenges. They needed to locate and memorize where they could find food and shelter, and do so without attracting attention. "Such ecological demands were, in fact, a great driver of crow and chimp intelligence," says Schnell. "And we believe the octopuses experienced similar environmental challenges."

Escaping the confines of a shell freed octopuses to travel, to manipulate objects, to learn, to remember—and even, perhaps, to imagine the workings of other minds: Minds that could be at once startlingly different from and yet thrillingly similar to their own.

A day octopus floats in the open ocean near the Big Island of Hawaii.

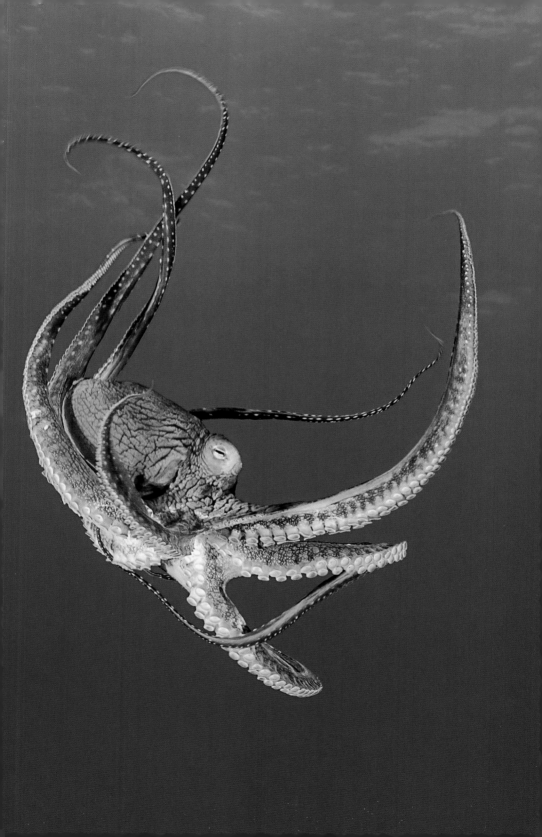

IT IS NIGHT. Heidi, a young day octopus, has plastered her suckers to one wall of the tank that sits in the living room at the home of Alaska Pacific University ethologist David Scheel and his teenage daughter, Laurel. The octopus's skin is white and smooth. Her mantle hangs limp, below her head. Her arms are at rest; her eyes look closed. She seems peacefully asleep, blissfully unaware of the video camera recording her behavior.

And then, her skin turns lemony. Papillae rise; she flashes maroon, then goes white again. Her mantle throbs like a beating heart; her color darkens, then mottles, yellow veined with brown, her texture thorny. Her bulbous eyes swivel in their sockets beneath closed lids. Her mantle seems to percolate like an old coffeepot. The curled tips of her arms twirl.

But she remains glued to the glass.

There's nothing going on in her tank to explain why she's changing color, texture, and shape. No food is present. There are no shadows overhead, no change in temperature or water quality, no movement inside or outside the tank to disturb her.

Scheel suggests what might be happening. Viewing the footage later, he provocatively proposes that Heidi may be responding to an interior drama—one that plays out in the nightly sleep of all mammals.

"If she's dreaming," the red-headed professor muses as he views the film of her abruptly turning from light to dark, "this is a dramatic moment." He imagines that in her dream, she might be hunting, then capturing, and finally retreating to devour a crab.

Part of a 2019 PBS documentary *Octopus: Making Contact,* the video clip of Heidi sleeping went viral, and it ignited a lively debate. Freud considered our dreams the poems we tell ourselves at night. Do octopuses, too, refresh their donut-shaped brains with their own kind of watery poetry as they sleep? Can we read the dreams of an octopus on the canvas of its skin? From a laboratory in Brazil to the waters of the West Indies, researchers are trying to find out.

The first step—as cephalopod neuroscientist Sylvia Lima de Souza Medeiros discovered at the Brain Institute of Brazil's Universidade Federal do Rio Grande do Norte—was to make sure her four island octopuses were really asleep.

Sometimes, it's hard to tell. Like mammals, her octopuses choose a preferred resting spot to sleep. Like us, they assume a typical sleep posture. In their case, head lowered and arms wrapped around the body. Like us, they slow their breathing at the beginning of sleep. But the eyes of a sleeping octopus might remain open, though the pupils contract to slits. An octopus awake, like one sleeping, might stay still for long periods. A number of different animals appear active when they are sleeping. By sleeping just one half of the brain at a time, whales and dolphins surface to breathe during their slumbers. Migrating frigate birds briefly sleep on the wing during soaring and gliding flight.

To be sure she knew when they were sleeping, Medeiros checked her octopuses' responses to various stimuli, following the principle that a reduced rate of response to stimulation is part of the definition of sleep. She and her colleague Mizziara de Paiva rigged up a nylon string in a separate room to activate a rubber hammer to bang on each octopus's tank. They tested four different intensities. They also tested a different kind of stimulus: Right in front of each octopus's favorite place to rest, they placed a screen on which they played a video of a scuttling crab—an image the octopuses would invariably attack when awake. They recorded the activity of the animals continuously for 12 hours during the daytime, and all the time during the stimuli test, to double-check when there was a reaction. If an octopus reacted to none of the stimuli, they knew that animal was, in fact, asleep.

---

FOLLOWING PAGES: Marine biologist David Scheel cared for this octopus—named Heidi— in a home aquarium. He reported that when his family watched TV, Heidi would watch along from her tank.

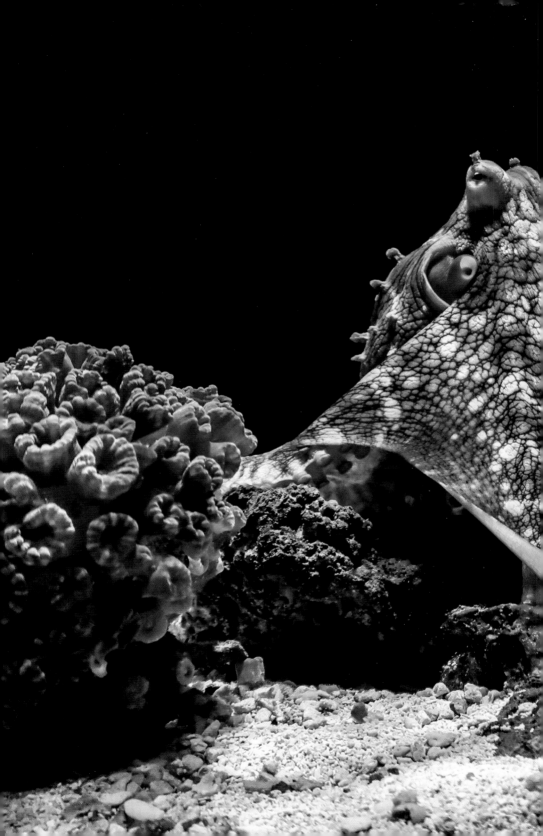

What Medeiros found was that octopuses, like humans, have two distinct stages of sleep, which repeat over and over until they wake up. She was making the final corrections to the draft of her paper when the film clip of Heidi's slumbers aired—and confirmed her results.

The first phase of sleep, like Heidi's, is what Medeiros terms "quiet sleep." The octopus is pale and motionless, eyes narrowed. This phase lasts several minutes—an average of 415.2 seconds, she found. Then, as in a sleeping human, this phase is followed by a distinctive new one, which Medeiros terms "active sleep." Breathing quickens, eyes dart, suckers clutch, arms twitch, and—most intriguingly—colors and patterns stream across the skin. This phase is short—it lasts about 40 seconds. And then the cycle starts over again. She found the octopuses in her lab averaged 10 "active" sleep periods and 17 "quiet" periods per day. (Preliminary tests conducted by Leite and colleague C. E. O'Brien found that individual octopuses tested in the wild have between two and nine different episodes of such "quiescence" per 24-hour period—and that they may sleep in spurts both day and night.)

In her *iScience* paper, published in 2021, researcher Medeiros is careful not to invoke the label REM (rapid eye movement) sleep. REM sleep is the phase during which humans experience dreams. It can be identified only by electrodes placed on the head—which can't be done with octopuses. They would pull them off. Plus: slime.

"As a scientist, I can't probe their dreaming," Medeiros says. But there's good reason to suspect that for these brainy animals, who need excellent memories and quick wits to solve new problems every day, "active sleep" might perform the same memory-consolidating function as dreaming sleep appears to do for humans. "We know in humans, when we dream about a test, we do better on that test the next day," she points out. "Their brain, too, captures a lot of information—and this requires some way to process and consolidate it."

But how to make sure such remarkable behavior is not produced in response to the abnormal situation of captivity? "It's a legitimate question,"

Medeiros acknowledges—which is why she is collaborating with O'Brien at the School for Field Studies Center for Marine Resource Studies at Cockburn Harbour, Turks and Caicos. As this book goes to press, they are filming three species, including both day-active and night-active animals, in the wild. "Nobody has previously managed to record this in the natural environment," O'Brien notes. They are mounting video cameras in front of octopus dens to film them continuously for 24 hours at a time.

While lab studies might yield results that apply only to captivity, field studies are beset with a different set of complications. Take the coconut-toting octopuses. It's tool use, yes. But today scientists report tool use is surprisingly widespread. Fish use rocks like hammers to bash open cockle shells, and wasps use pebbles to seal burrow entrances.

What most impressed Finn about seeing the coconut octopus lugging its load was that its burden was "of no immediate use to it." Carrying the shell "actually made it more vulnerable," he says. The slow, waddling gait could attract the attention of a predator. That the octopus makes an impressive effort, and risks immediate danger, to retrieve this tool for later use, Finn proposes, could be evidence it is planning for the future—like a person who brings an umbrella in case of rain.

But Christine Huffard knows these waters well, and she can well imagine such shells could be useful even before the octopus puts together two halves to make a shelter. "This habitat is full of mantis shrimp," she points out. These predators hide in the sand, waiting to ambush prey from below with powerful, spearlike forelimbs. Also lurking in the sand are stargazers, fish with top-mounted eyes and large, up-facing mouths who lie in wait to suck down unsuspecting animals whole. "If I lived in that habitat, and at any moment an enormous set of spears could spring out at me, I'd want to carry a shield around." While filming off Lembeh Island for *Secrets of the Octopus*, series director Adam Geiger and series host Alex Schnell saw an octopus go one better. "A mantis shrimp and a coconut octopus in its den were

having a battle," explains Geiger. "The octopus looks out and sees a shell. She brings the shell back to the den and puts it upright like a shield. It's clearly understanding what it can do with an object." Smart move!

But while the coconut octopus clearly uses tools, these field observations don't prove the octopus is planning for the future. To discover what the octopus is actually thinking will require careful experiments, combining laboratory findings with underwater observations.

"The lab experiments have yet to prove the extent of these animals' cognitive complexity," says Schnell. "But meanwhile, observations in the field sure inspire you!"

"And there's a lot to learn from people who keep octopuses in aquariums," adds Huffard. Each setting can provide a different facet of a mosaic—one

Off the coast of Mustique, an island in St. Vincent and the Grenadines, lives *Octopus insularis,* a southern Caribbean species recently distinguished from the closely related common octopus (*Octopus vulgaris*).

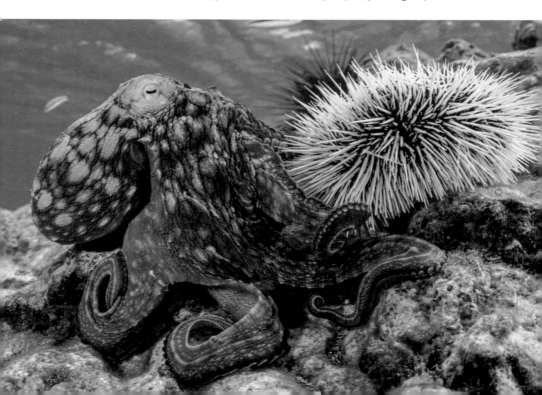

that researchers hope to assemble into a more revealing portrait of the octopus's mental world.

NANCY KING OF DALLAS, TEXAS, willingly admits it: She was trained by her pet octopus.

Some years ago, King maintained a 55-gallon (208 L) saltwater tank to house a small, wild-caught female California two-spot she named Ollie. Ollie soon learned to associate King with the appearance of food, and the octopus would come to the front of the aquarium when she spotted King through the glass. King dropped live fiddler crabs into Ollie's tank. When the crabs burrowed into the sand, the octopus seemed to have trouble finding them. From outside the glass, King used her index finger to point out the hiding treat, and Olly learned to hurry over and dig for the crab at that spot. The filmmakers for *Secrets of the Octopus* were amazed to record the same thing in the wild while they filmed Schnell following a day octopus hunting crabs, and one got away. As the cameras rolled, Schnell pointed to the crab with her finger—and the octopus came over and seized it. Dogs and elephants are the only other species that researchers have shown to understand and respond to a human pointing. Even wolves raised in captivity don't seem to get the idea.

King soon discovered that the learning went both ways. One day she was out of Ollie's room when she heard a crash near the tank. King rushed in to investigate. On the floor was a magnet, part of an algae-cleaning tool normally held in place by a second magnet inside the glass. When Ollie had pulled it, the outside magnet had let go and fallen, making a racket, which brought King to the tank to investigate. From then on, the octopus learned to pull off the magnet to summon her human keeper—and King

learned to respond to the sound and hurry to the tank to entertain her companion. Ollie also succeeded in training King's husband. Like servants summoned to serve a meal at an English manor, "we would come running" every time Ollie pulled the magnet, says King.

In the book *Cephalopods: Octopuses and Cuttlefish for the Home Aquarium,* King and her co-author, Colin Dunlop, note that captive octopuses are inquisitive creatures who seem to enjoy having something interesting to do. "After water quality and feeding, the stimulation and enrichment of a cephalopod's life [are] most important," they stress. Octopuses enjoy working puzzle boxes and opening jars to get at food inside. The authors recommend offering the home octopus the same toys you would give your children. They like dismantling, and sometimes putting together, Lego bricks. They like to take apart Mr. Potato Head.

In other words, they play.

Play is another activity associated with intelligence. In laboratory rats, the opportunity to play leads to larger brains, particularly the prefrontal cortex, the area involved in planning complex behaviors. A University of Arkansas study found that children who play more often with toys have higher IQs by age three. And an analysis of 46 studies on children found playing enhanced the kids' thinking, reasoning, and remembering, as well as their social development and language skills.

Sometimes octopuses behave so much like children they seem to be playing the same games. At the Seattle Aquarium, the late Roland Anderson was conducting an experiment he'd devised with Lethbridge University psychologist Jennifer Mather, one of the leading experts on octopus problem-solving and personality. He gave each of the eight resident giant Pacific octopuses pill bottles to explore their preferences in color and texture. Some carefully examined their bottle with their suckers; some cast their bottle off; and a few held it at arm's length, as if regarding it with suspicion. But two octopuses did something radically different: They squirted it with their jets—with a

stream "carefully modulated so that the pill bottle was caused to circle around the tank over and over." By the time one female octopus had repeated this action 16 times, Anderson was already on the phone with Mather with the news: "She's bouncing the ball!" he told her.

While play may later prove useful—lion cubs pouncing, for instance, prepares them to hunt as adults—by definition, play is an activity performed at the time for pure pleasure. While playing, animals are not searching for food or mates—activities essential for survival itself. But for intelligent creatures, from children to chimps, play is essential for health and happiness. Smart animals become bored and depressed without something to do. That's why the Cleveland Metropark Zoo developed an enrichment manual for captive octopuses, which is now used by dozens of zoos and aquariums. The manual encourages that keepers, besides providing live prey and interesting hiding places, offer their charges toys like baby teething rings, building blocks, hamster balls, and plastic dog toys.

Various aquariums developed even more elaborate amusements. Wilson Menashi, an engineer with several patents to his name, was tasked by Boston's New England Aquarium staff to develop a toy sufficiently challenging to keep their giant Pacific octopuses occupied. He created a series of three different-size plexiglass boxes, each with a different lock. The smallest has a sliding, twisting lock, like the bolt on a horse's stall. The next size up has a latch that catches on a bracket. The third has two locks: one bolt and the other a lever arm like one on the lid of an old canning jar. The octopus learned to open all three boxes to get to a live crab inside. For even more octopus entertainment, the boxes could nest one inside another like a Russian doll.

Keepers at SEA LIFE Kelly Tarlton's Aquarium in Auckland, New Zealand, taught their female giant Pacific octopus, named Rambo, to thread

---

FOLLOWING PAGES: A giant Pacific octopus glides across the ocean bottom, propelling itself by filling its mantle with water and then jetting the water out through its siphon.

her arm down a tube to press an orange button to take photos of visitors with a waterproof digital camera—making her the world's first documented "octographer." Other institutions have encouraged their octopuses to exploit their artistic talents. Oregon State University's Hatfield Marine Science Center devised a system of levers that allowed its giant Pacific octopus to move a series of paint brushes against a canvas outside her tank. After the first octopus painter, Squirt, became a sensation, other aquariums in Tennessee and Florida trained more octopus artists.

But octopus creatives do not always cooperate with their human patrons. Rambo learned how to snap photos in only three tries—but she also quickly learned how to crush and destroy the camera and its housing. (Staff solved this problem with a redesign.) And while all of the New England Aquarium's giant Pacifics quickly understood how to open the puzzle boxes, one day an impetuous female named Guinevere found a quicker way to get to the crab inside. She just crushed the box, creating a crack through which she seized the crustacean. Later, an octopus named Truman also chose not to bother with the locks. Normally laid-back, Truman was excited because his keeper had put not just one but two live crabs in the innermost of two boxes, and they were fighting irresistibly. Truman simply flowed his entire body through the crack his predecessor had made in the outer box to get inside. (Unfortunately for Truman, he was squeezed into the space between the inner and outer boxes and got stuck. His keeper saw his dilemma and opened both boxes for him so he could devour the crabs.)

Aquarium caretakers and home aquarists report that many octopuses appear to appreciate human company just as much as they enjoy puzzles and toys—like Ollie and the Kings. A series of experiments at the Seattle Aquarium, conducted by Mather and Anderson, showed what octopus keepers already knew was true: Giant Pacific octopuses recognize and remember individual human faces. The researchers divided identically dressed human volunteers into two groups. One group would lean over

the tank and offer a tasty fish. The other would touch the octopus's skin with an unpleasantly bristly stick. All the octopuses in the study quickly learned to approach the people who had previously offered fish—even when no fish were on hand. But when the octopuses looked up through the water at the faces of those who had touched them with the bristly stick, they swam away—often after squirting the person in the face with cold salt water.

There are many accounts of octopuses who seemed to relish human friendship. In his Oscar-winning film *My Octopus Teacher,* free diver and filmmaker Craig Foster repeatedly meets up with the same wild common octopus in a South African kelp forest. When they do meet up, although she could easily escape him, she allows him to travel with her almost every day for more than a year, and allows him to stroke her as she explores his skin with her suckers. In David Scheel's Anchorage living room, his daughter, Laurel, and their octopus, Heidi, often played together with balls and jars. When it appeared the weight of the tank would collapse the floor at his home, Scheel was forced to move Heidi to his university lab. When Laurel came to visit, Heidi flushed red with excitement and rushed to the front of the tank to greet her.

Why should a famously solitary animal, one that experiences no maternal care and eschews group living, form relationships such as these? How could an animal whose natural history includes no social life form bonds that look surprisingly like friendships?

"New evidence is crushing cephalopod biology hypotheses that were assumed to be true for many decades," says Huffard. Some of her findings—like those of other maverick researchers—were at first dismissed or ignored because they were so surprising. But now it appears that at least some species of these shockingly smart creatures may not be so solitary after all—and their relationships with one another, and with other species, are far more rich, complex, and intriguing than we ever thought possible.

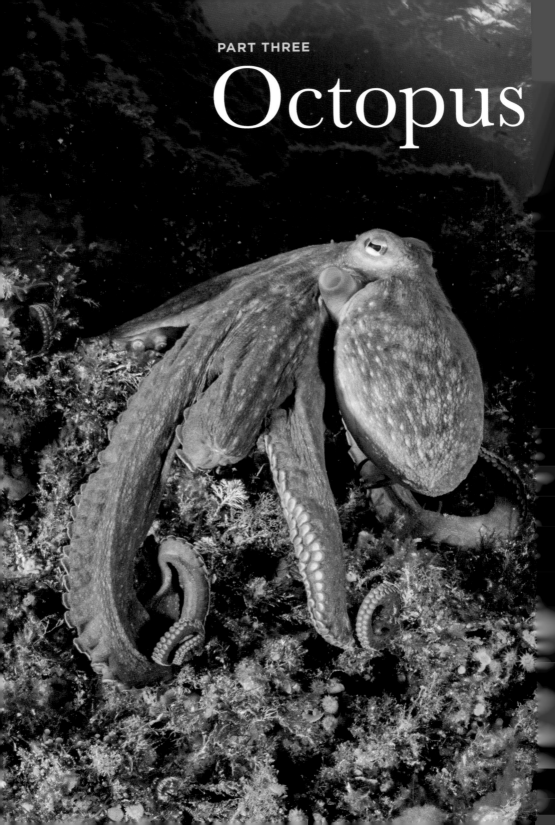

# Octopus

# Kingdom

UNEXPECTED ASSOCIATIONS

The top of the 3,000-gallon (11,356 L) tank is strung with heart-shaped lights; a bouquet of red plastic roses floats in the water; and over the sound system Barry White's deep, sexy bass booms, "Can't get enough of your love, babe." It's February 14, and the Octopus Blind Date is under way at the Seattle Aquarium.

"It's crazy, but it's pretty amazing," said the cameraman filming the annual event for the Seattle NBC affiliate. Thousands of visitors, including busloads of schoolchildren, flock to the aquarium—all to watch what happens when 16 arms, 3,200 suckers, and copious natural lube come together as an adult male and adult female giant Pacific octopus are released into the same tank.

"They mate on Valentine's Day?" asks a visitor. "How do they know it's Valentine's Day?"

"They're doing it? Where's the other one?" wonders another. The visitor doesn't realize she's looking at not one octopus, but two, blissfully conjoined in the typical mating position for this species. The male covers the female with his arms, web, and bag-shaped mantle as he uses his specialized third right arm, the hectocotylus, to place his sperm packet inside her mantle opening—the same opening with which octopuses inhale water to oxygenate their gills. Aristotle described the setup (not completely inaccurately) by explaining that the male "has a sort of penis on one of his tentacles ... which it admits into the nostril of a female."

A diver illuminates a giant Pacific octopus.

PREVIOUS PAGES: This common octopus in the Mediterranean Sea seems to have a follower, a fish called a painted comber (*Serranus scriba*).

"It's funny to think they come to see two animals mate," says the aquarium's lead invertebrate biologist, Kathryn Kegel. As is thought to be the case with most octopus species, giant Pacifics mate only at the end of their short lives. Females lay a single clutch of 100,000 eggs and then, after guarding and cleaning them for an average of six months, die shortly after the hatchlings emerge.

But the act of mating can be a fraught affair—because sometimes the blind date turns into a dinner date, when one octopus eats the other.

One year at the aquarium, the female killed the male and began to eat him—though it was after their mating and not in front of the public. The unfortunate episode occurred while the pair was in a holding tank, awaiting release back to the sea. But the possibility of such violence recurring is the reason why the aquarium ultimately canceled the annual Blind Date event in 2016, despite an extremely popular run of a dozen years.

Captivity itself, though, doesn't cause cannibalism. The open ocean is no guarantee of safety from one's suitor. On a dive off the island of Palau, Micronesia, Roger Hanlon watched a female Pacific day octopus as she was pursued by a male half her size. He followed the female for more than three hours and about 75 yards (69 m) as she foraged. The male "flinched backwards whenever the female moved toward him," he reported. Clearly aware of the danger but undeterred, the little male managed to mate with her 13 times, each bout lasting an average of six minutes, never longer than half an hour, and always at a careful distance.

"Distance mating" is the male day octopus's version of safe sex. Shrinking away in the opposite direction as far as he can, he reaches out to the female with only his third right arm to eject the large sperm packet from his mantle into hers. This strategy gives him the best chance for escape if the romance turns sour. (And if she bites off his hectocotylus, at least he can grow another.)

Hanlon's male, alas, was not so lucky. During the 13th tryst, the female abruptly turned toward her lover, engulfed him in her web, and swam off,

with the male "struggling and inking, completely wrapped in her arms," the scientist reported. She returned to her den and spent the next two days feasting on her mate.

Octopuses don't confine their conspecific snacks to sexual settings. In Alaskan waters, researcher David Scheel attached a radio tracking device to an 11-pound (5 kg) giant Pacific. The next day he followed the signal—only to be led to a completely different, 35-pound (16 kg) octopus with no telemetry tag. Why was this octopus beeping? Because it had eaten the smaller octopus, whose tracking device was still working fine.

Cannibalism is well-documented among many species, including humans (one 12th-century Chinese cookbook contains recipes for human flesh). Yet, possibly because the practice is generally frowned upon in academia, eating a member of one's own species is considered the nadir of antisocial behavior. So the inclination of octopuses to eat one another, plus the fact that researchers seldom reported seeing octopuses together, seemed to validate the notion that octopuses were loners.

For decades, it was accepted scientific dogma: Only copulation or cannibalism brought octopuses together. Unlike for most birds, mammals, and many fish, there were no accounts of octopuses living together in groups, no reports of complex mating strategies, no descriptions of social skills, and no records of associations or affiliations with other animals—except to eat them.

But for a growing number of octopus species, and in an increasing number of places, divers and researchers are documenting that this belief turns out to be breathtakingly wrong.

AS A DOCTORAL STUDENT at the University of California, Berkeley, Christine Huffard had heard the stories before: Octopuses are solitary.

Mating happens only when male and female blunder into each other. If all goes well, they each go their separate ways; if not, somebody gets eaten.

But over her field seasons studying wild algae octopuses in Sulawesi, Indonesia, that was not what she was seeing.

Snorkeling and wading with her study animals just off the beach, Huffard was able to identify and track 167 individual algae octopuses. And they were showing her social behaviors worthy of a soap opera.

Rather than randomly bumping into one another, males appeared to actively seek out particular females, often even skipping meals to follow them around. While mating with and defending these females, the males wore their most conspicuous pattern of black-and-white stripes and erected jaunty papillae over the eyes. And when it came to selecting a mate, some octopuses, at least, had favorites.

Huffard noticed numerous instances in which a certain large male octopus chose to mate repeatedly with a particular female—and the couple stayed together over the course of several days. Sometimes a mating pair even built neighboring dens, within two feet (0.6 m) of one another. Often this was close enough that the male could extend his hectocotylus (which can stretch to twice its resting length) from the comfort of his own den to that of his neighbor, mating with the female without leaving home. While not engaged in intercourse, the male might stand tall at the den entrance, guarding his mate.

And if a second, smaller male tried to move in on the female, the male resident made his displeasure known. He rushed aggressively toward the interloper, turning up the contrast of the light and dark stripes along his body. The signal was clear: *Stay away.* If the smaller male continued his approach, Huffard reported, the guarding male attacked and wrestled the intruder. "The big males always chased the smaller ones off," she observed. On a few occasions, she noted, a guarding male held the end of his rival's funnel or wrapped one arm around the mantle opening over the gills, attempting to choke him to death.

These paired-up males and females weren't above mating with others, however. Huffard observed that when taking occasional solo jaunts away from the den, both males and females might mate with another individual. But then they would return to the paired dens—and to their mate next door.

While the guarding males were not watching, sometimes "their" females would receive other gentlemen callers. On three occasions, Huffard documented the efforts of "sneaker males," as she calls them. In full cryptic camouflage, a smaller male would flatten himself to the ocean floor and creep stealthily toward the den entrance of a guarded female. Hiding most of his body from the guarding male behind rocks, he would elongate his mating arm and stretch it into her den.

This algae octopus (*Abdopus aculeatus*) has released its ink cloud. Researchers have found ink sacs in octopus fossils dating back more than 300 million years.

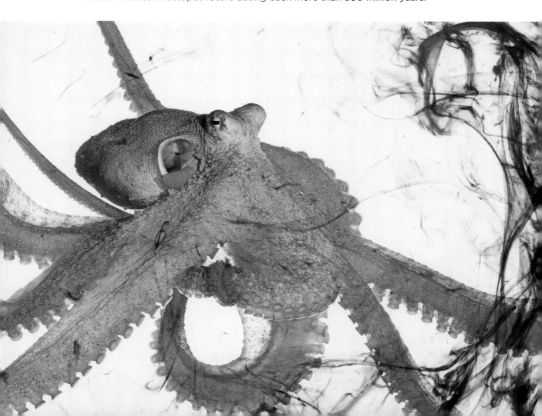

Reporting this behavior in her doctoral 2005 thesis, Huffard describes it as "the most complex mating behavior observed thus far for any octopus species."

Today, however, Huffard is quick to acknowledge that even more unexpected social behavior in a different octopus species had actually been recorded by another scientist a quarter century earlier. But almost nobody knew about it.

In the 1970s, Panamanian biologist Arcadio Rodaniche observed beautiful octopuses that were previously unknown to science and not yet named doing incredible things. With a mantle only two to three inches (5 to 8 cm) long, the animals could morph from a dark reddish brown to a riotous combination of black-and-white stripes over a night sky of white stars, a pattern so striking that the researcher dubbed the new species the "harlequin octopus." From the murky intertidal waters off the coast of Nicaragua, Rodaniche captured dozens of the gorgeous little animals and raised them in a saltwater pool at the Smithsonian Tropical Research Institute in Panama. What they did there defied everything known then—and for decades to come—about octopus social behavior.

Males and females mated not at a distance, not one atop the other, but in the most tender and vulnerable position imaginable: mouth-to-mouth, suckers-to-suckers. Pairs sometimes shared dens. Groups of animals—sometimes 40 or more—lived in neighborhoods. And while in most other octopus species the females lay a single clutch of eggs, only to die when they hatch, the harlequin females raised brood after brood over their two years of life.

Rodaniche's observations "were so outside the norm of what biologists at the time thought octopuses did," comments Roy Caldwell, a marine biologist at the University of California, Berkeley, that "they were dismissed by other cephalopod biologists." Huffard has seen the handwritten reviews rejecting the paper. "The reviewers were nasty," she says. "They felt the

observations were not valid. They said he wasn't even qualified to make these observations. And at that point, octopuses weren't considered that interesting by journal editors—so why bother to publish it?"

Rodaniche's paper was rejected; the new octopus was ignored. And then the species disappeared. No other specimens were seen for about 25 years.

Then, in 2012, Richard Ross, a senior biologist at San Francisco's Steinhart Aquarium, was able to obtain harlequin specimens from collectors—and with Caldwell, he documented and confirmed many of Rodaniche's stunning observations, with equally stunning photographs and videos. In captivity, one mated pair even shared a meal. The two octopuses held a shrimp politely between them, and consumed it beak to beak, rather like the romantic spaghetti scene in *Lady and the Tramp.* Vindicated, Rodaniche joined Caldwell, Ross, and Huffard to publish these behaviors. Rodaniche died in 2016.

Now the animal is known by the common name "larger Pacific striped octopus," but it still awaits a binomial scientific classification. Ross describes the dazzling little creatures as "the coolest things on the planet."

Is this gregarious species' sociability unique among octopuses? Apparently not. Studies of another, related species, confusingly called the lesser Pacific striped octopus (*Octopus chierchiae*), now appears to share many of its larger relative's behaviors. So does an even more mysterious Japanese species, *Octopus laqueus,* whose existence was first described in 2005. It still has no common name, and no detailed scientific account of it has been published in English. Members of this species also live in close proximity in the wild, and males and females have been observed sharing dens.

"There is still an awful lot to learn," Huffard says. For even species of octopus thought to be well-studied continue to surprise us.

---

FOLLOWING PAGES: Two giant Pacific octopuses form a mating pair. The gray female is actually larger than the red male.

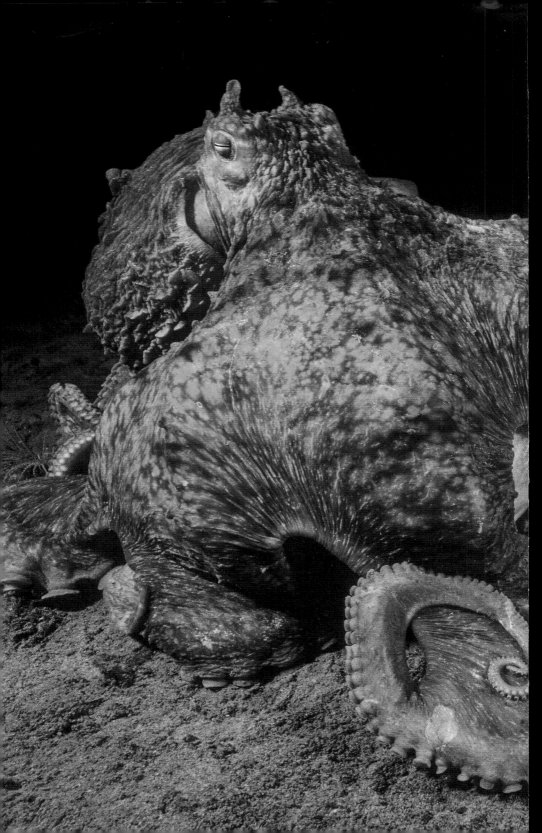

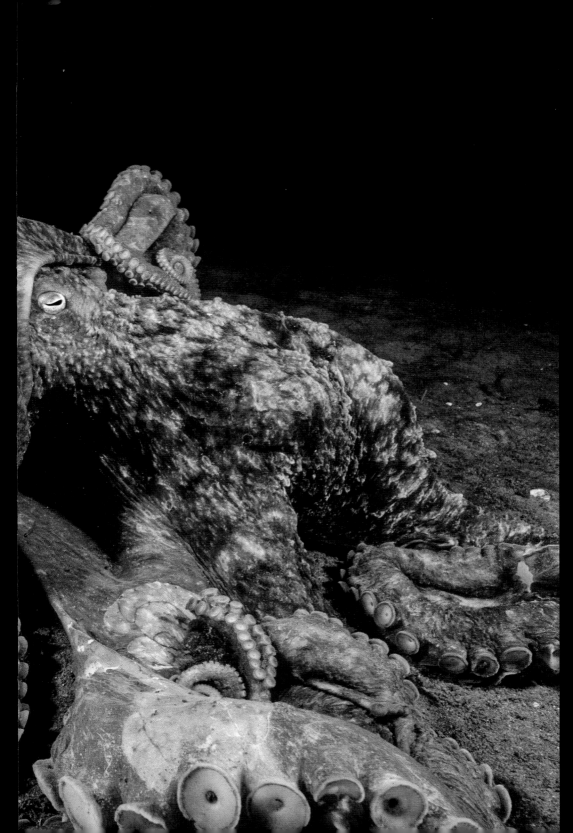

IT SOUNDS LIKE A FAIRY TALE: Sixty feet (18 m) beneath the waves, at the sandy bottom of the ocean, in waters that, on sunny days, shine as green as Oz's Emerald City, there is a great and bustling metropolis. Its citizens are busy bringing home food, tending their homes, pursuing romances, and dealing with theft and intrigue. There's even a neighborhood gossip. And the place is inhabited entirely by … octopuses.

An accomplished Australian diver, Matthew Lawrence, discovered such a place in Jervis Bay, off the east coast of Australia, in 2009. Here, among a bed of scallop shells piled around a foot-long piece of sunken metal, up to 16 octopuses have made their homes.

The inhabitants are all common Sydney octopuses—a species thought to be solitary. Peter Godfrey-Smith, an avid diver and philosophy professor with a dual appointment at universities in New York and Sydney, learned about the place online. He was curious: What was going on there? He began to dive the site with Lawrence to observe the citizens of this "octopus city." The men dubbed the site Octopolis.

Sometimes there was so much activity that, to Godfrey-Smith, the scene seemed like "multi-armed chaos." Multiple octopuses roved at once over the shell bed. They jetted away, lashed at each other with arms, stood tall and turned dark, then sometimes shrank down and turned white. They brought home food, took out the garbage (removing uneaten food and debris from a den with their arms and, sometimes, by using their siphons like leaf blowers to clear it from the entrance), and at times just sat at their den entrances changing colors, like people sitting on their front porch, considering the comings and goings of neighbors.

Octopuses chased each other. They wrestled. At times they seemed to high five one another, almost in greeting. Other times, seemingly in annoy-

ance, they hurled armfuls of shells in the direction of their neighbors—and sometimes the projectiles found their mark. (This finding was so unexpected that the first three journals the team approached for publication rejected their paper. It was eventually published in the journal *PLOS One* in 2022.)

Recruiting Alaskan ethologist David Scheel to join them, the men filmed the octopuses' interactions—both in person during dives and afterward, leaving GoPro video camera systems on tripods behind to record the action.

One of the activities often recorded was an octopus seizing a GoPro and attempting (sometimes successfully) to drag it back to a den. Once, their video captured a second octopus attempting to steal a GoPro from the first. But when the cameras were stationary enough to record the animals' behavior, intriguing patterns began to emerge.

From identifying marks like scars and bite marks, the researchers learned to recognize about one-third of the individuals they watched. It seemed that the octopuses recognized individuals, too. In one remarkable instance, a female octopus, who denned next to a particular male, saw an intruder male approaching. The female left her den, grappled with the rival male, and returned home. But the intruder then entered her neighbor's den and evicted him. The female attacked. The two came out of the hole wrestling, and the researchers could see one of her arms wrapped under his mantle, attempting to find the gill opening—"a killing hold in octopus battles," Scheel notes. The rival male retreated, and the female scuttled back to her original den. Soon her neighbor returned to his rightful home, too. The female touched him on the head with one arm, the two tussled briefly, and then they settled right back into their neighboring dens as before.

Scheel recounts the scene in his 2023 book, *Many Things Under a Rock: The Mysteries of Octopuses*. Clearly, the female could tell the two males apart, he writes—though it was not clear whether she did so by sight, by chemical cues, by location—or by some other method. The outcome of this

interaction suggests that the female octopus may have also relied on her memories of past interactions with each, suggests Scheel—"trusting one to be trouble, and the other to be a congenial neighbor."

In Octopolis, social relationships and interactions are so numerous, and possibly so consequential, that it even appears that one particular octopus—always a large male—assumes the role of watching over them all. Scheel describes this male's behavior, as seen in one of many similar sequences recorded on video. In this instance, "another female exited her own den near the center of the shell bed, edging off the site. The male redirected toward her and trailed this female to the edge of the shell bed. He was reluctant to follow farther. [But] minutes later, an octopus approached from off-site, bearing the rewards of a foraging trip … The large male alerted, raising his eyes and turning dark. Then he stood tall on his arms, mantle behind him rising from a relaxed position." The two touched, he lightened, and he escorted her back to her den. The big male behaved similarly toward the next arrival to the shell bed.

In other words, Scheel writes, this one particular octopus "attends to every octopus that moves." Scheel calls the octopus who occupies this role the quidnunc—a term for a gossip or busybody, first coined in 1709 by Sir Richard Steele in his famous periodical *The Tatler*. The quidnunc, of all the octopuses in Octopolis, "is the most active individual. In his attention, it is as though he were gathering local gossip, asking 'What now?' when an octopus moves in the den, or 'Who is that?' when one returns to the site," Scheel writes. In the many years the team has visited the site, there is always one octopus occupying this role, though, because of octopuses' short life spans, it is not always the same individual. But the role of the quidnunc persists.

A Brazilian reef octopus belonging to the species *Octopus insularis*
peeks out from her cluster of eggs.

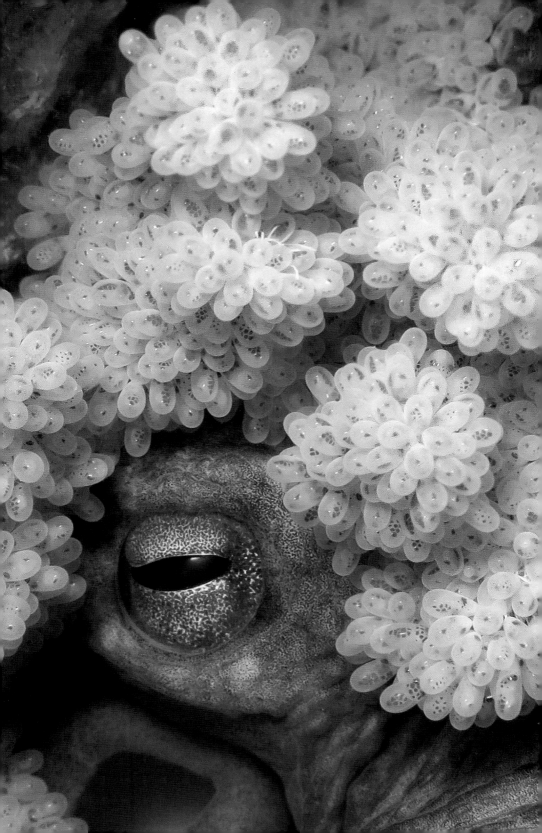

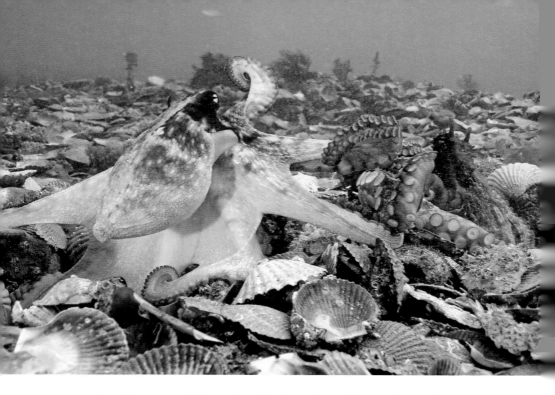

A mating scene amid the scattered detritus of Octopolis, near the Australian coast

Why would such a position arise? Why might an ability to remember and recognize individuals be important in Octopolis but not at other sites where the same species is found?

Godfrey-Smith notes that Octopolis is an unusually alluring site for common Sydney octopuses. To the first octopus who found it, the unknown metal object that underlies the shell bed (perhaps something that fell from a cargo ship long ago) offered a rare resource: a protective covering for a den that could be dug beneath it, which would offer greater safety than just a hole in the sand. Surely other wandering octopuses would have also noticed the advantages of the spot. The scallop shells that began to accumulate around it—remains of meals the founding octopus enjoyed—further enhanced the site. Shells make more stable dens than sand does. This would have attracted more octopuses, who brought in more shells, which brought in more octopuses, and so on.

Octopolis was founded, like many of the world's mighty cities, in a great location. The nearby scallop bed offered plenty of food. The metal ceiling of the den offered protection from predatory seals, dolphins, and sharks. The many shells offered a stable substrate. Octopolis arose as "an island of safety in a dangerous area," Godfrey-Smith notes. But city living demands accommodating many close-by neighbors. To take advantage of a rare opportunity, perhaps the intelligent and insightful octopuses had to figure out a new puzzle: how they could all get along.

This would not be the first time a rare resource prompted unusual coexistence. When author Elizabeth Marshall Thomas lived among the San of Namibia in the 1950s, she quickly noticed that the people did not fear the lions, who never attacked them. The people did not bother the lions, either. Unlike elsewhere in Africa, where lions and people routinely killed each other, "the people and the lions had established a truce," she observed. She felt sure she knew why: Both had to share scarce water in the desert. The humans visited the waterholes by day, and the lions came at night. The truce allowed creatures who elsewhere were enemies to live in harmony, permitting both to safely exploit an essential resource.

The octopus community at Octopolis may be uncommon, but it's not the only octopus "city." In 2017, not far from Octopolis in Jervis Bay, the research team discovered another aggregation of Sydney octopuses. They call it Octlantis.

THE WORLD'S ROUGHLY 300 species of octopus (so far) are likely as varied as the world's 400-plus species of primates. The larger Pacific striped octopus, for instance, may be as different from a giant Pacific octopus as a tree-living, 13-ounce (369 g) marmoset is from a human. Nobody expects

all octopus species to behave the same way. While male algae octopuses have been documented carefully choosing mates, blue-ringed octopuses apparently do not. In fact, blue-ringed males have been observed handing out sperm packets like after-dinner mints, to males and females alike.

Even closely related species may exhibit remarkably different behaviors. Gorillas differ from orangutans in less than 2 percent of their DNA. Yet gorillas live in close-knit family groups of five to 10 animals, sometimes up to 50, while—other than occasionally courting pairs, or a mother traveling with her single youngster—orangutans are usually found alone.

Different settings may sculpt different behaviors and different social groupings even among the same species. In Australia, Huffard never saw the algae octopus engage in social behavior or displays—perhaps, she muses, because there were too many predators around. In most places scientists have studied them, it appears the common Sydney octopus doesn't commune with others as in Octopolis and Octlantis. But then people behave differently in the country than in the city, too. You'd not expect to see a person hailing a cab or riding a subway in a rural area—any more than you'd likely spot someone driving a tractor in New York City.

Just because one species, or two species, or even several species of octopus do something at one place, it doesn't mean they all do it everywhere. This leaves scientists in a familiar situation: The world is more complex than we thought. We need to pay closer attention. "We need more study," says Schnell. "We need more experiments, more fieldwork, more people out there making observations." And not just professional marine scientists and ethologists. Anyone with good eyes, and an open mind, may make an important contribution. Even a kid in elementary school.

Rehan Somaweera is one of those kids.

WITH HIS DAD, ecologist Ru Somaweera, Rehan always loved snorkeling around the shallow, temperate reef near their home in Perth, Australia. Unlike a tropical coral reef, the bottom here is mainly algae-covered boulders, rocks, and sponges. But more than 100 species of fish gather in this small reef, from the handsome banded morwong to the bewhiskered goatfish, from the angelfish-shaped sweep to the brownspotted wrasse with its skin spangled with tiny dots. But of all the reef's inhabitants, Rehan's favorite was the star octopus—a species only recently distinguished from the common Sydney octopus and given the common name star octopus and the scientific name *Octopus djinda,* after the local Nyoongar people's word for "luminous."

"They are curious. They are so different from any other sea creature," Rehan says. "Sometimes they go up to your hand and grab you. So when I see octopus while snorkeling, I always have a closer look."

The boy often found that an octopus would allow him to tag along as it went about foraging. One day, as the octopus he was accompanying probed its arms into crevices hunting for snails, Rehan noticed something odd. He was not alone in following the octopus. The entire 15 minutes they were together, a particular brownspotted wrasse was following, too. And to Rehan, it was clear why: "The octopus is moving around and scaring all the little creatures on the bottom," he says. A cloud of small invertebrates would scurry out of the way—and the fish would slurp them up.

Though he "thought it was kind of cool," the youngster didn't say anything about this to his dad. But over the next few weeks of snorkeling together, "it kept happening," he explains. Seven or eight different times, at various different locations. "It was happening *a lot,* but I didn't think it was a major discovery." Finally, though, he mentioned his observations to his father.

FOLLOWING PAGES: A coconut octopus (*Amphioctopus marginatus*) patrols the ocean floor with a cargo of protective shells.

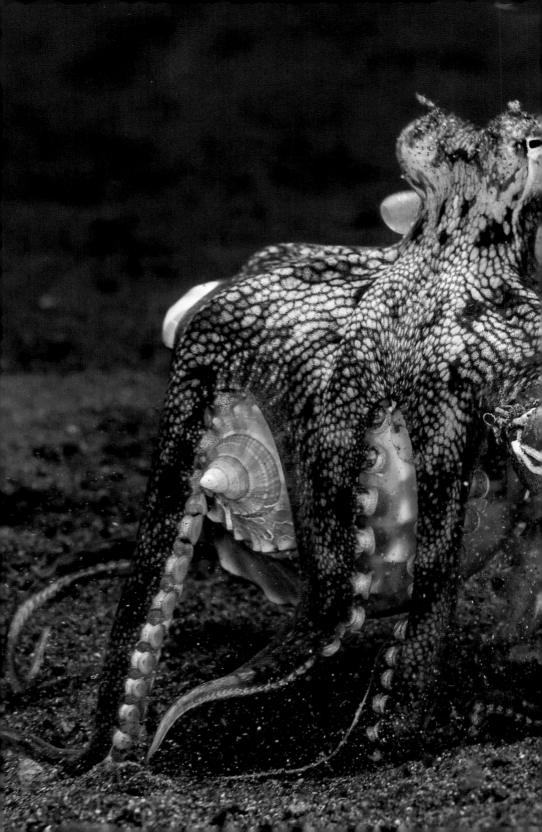

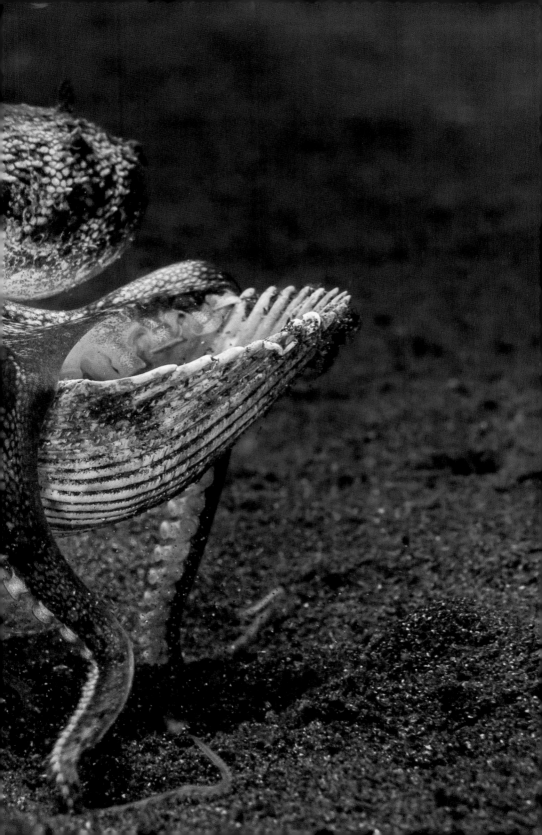

The elder Somaweera is an internationally recognized reptile specialist, with a particular interest in sea snakes. Observing and photographing other marine life is otherwise "just a hobby," he says. But he thought his son's observations interesting. Once he saw the behavior for himself, he knew it was worth investigating in detail.

As he looked into it, Somaweera found other reported instances of fish and octopuses hunting in close proximity. Jennifer Mather, Roger Hanlon, and others have documented fish—sometimes multiple species of fish at once—following both day and common octopuses and feeding on prey flushed out by their cephalopod compadre.

In 2013, a team of researchers from Switzerland and England published observations of behavior even more complex and compelling. Speedy coral trout will actually search out and alert a nearby day octopus to recruit its help—the first recorded instance of cooperative hunting between a vertebrate and an invertebrate. This cooperation was captured on film in *Secrets of the Octopus*: The fish signals the octopus by pointing, head down, at the hidden prey, shaking its head—and the octopus acknowledges this with a momentary flash of white on the head, and then moves to where the fish is pointing. African honey badgers and birds called honey guides do this, too. The bird leads the badger to a honeycomb, which the badger opens with strong claws, so both can enjoy the honey and protein-rich larvae inside. Other terrestrial species, including wolves and crows, and American badgers and coyotes, also cooperate to hunt for food.

Seven years before he and his colleagues reported the octopus-trout alliance, Swiss researcher Redouan Bshary had documented swift-swimming fish called groupers similarly recruiting sinuous moray eels to help them access hidden prey—the first instance of cooperative hunting recorded among fish. The groupers, like the coral trout with the day octopus, would approach the morays with a distinctive shimmy, swim to the site where the desired prey was hiding, and point to it by doing a headstand.

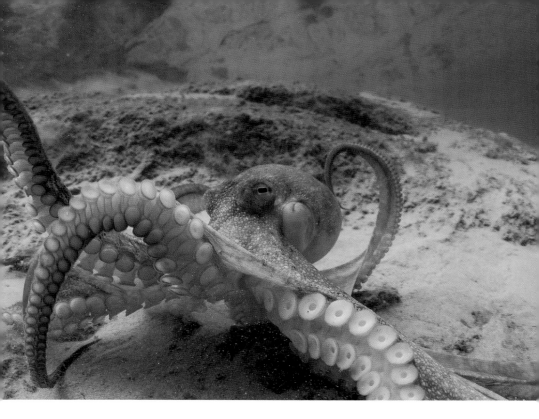

The star octopus (*Octopus djinda*) was reclassified as a distinct species only in 2021.

Such partnerships may be so important to octopuses that when they go wrong, the octopuses show visible frustration. A video released in 2020 created a viral sensation when it showed a day octopus who was hunting with a goldsaddle goatfish suddenly haul off and punch his partner. Maybe the goatfish just wasn't doing a good job, and the octopus was annoyed. Or maybe the octopus was cheating his partner. Whether the goatfish got socked for slacking, or the octopus was greedily knocking aside his companion to steal a meal, the researchers couldn't tell. But the team went on to record seven more instances of octos cuffing their fish partners, in both Israeli and Egyptian waters.

Back in Australia, the father-son team decided to investigate Rehan's observations further. Rehan's dad gave him an underwater dive slate and a dive watch so he could record his findings. Between March 2020 and

February 2021, they visited four different locations to check for octo-wrasse associations. They documented wrasses accompanying octopuses on foraging expeditions on eight occasions.

They carefully watched what both the fish and the octopus were doing. Rehan notes that "the fish was not bothering the octopus; it was not stealing the octopus's prey." It was eating only the far smaller animals the octopus ignored—animals who were "just in the way." Essentially, the fish was eating the octopus's bycatch.

What Rehan had witnessed, his dad said, may well have been "a common thing." Surely such an association had formed before, over and over, played out in front of hundreds if not thousands of other snorkelers and divers— but nobody else had paid it attention. "The octopus is so fascinating," Rehan says, "probably nobody noticed the fish." And what he saw may prove to be even more fascinating with further study. The team could see no benefit to the octopus from tolerating the wrasse—but they plan to investigate further. Possibly, suggests the elder Somaweera, the wrasse helps watch for predators while the octopus searches for prey.

Rehan noted and timed his observations. He even wrote a first draft of a scientific paper. Admittedly, his dad "changed and updated it a lot." But the 10-year-old appears as the co-author of the paper, published in July 2021 in the respected journal *Marine and Freshwater Research,* published by the Australian government agency responsible for scientific research. As per professional protocol, the first author lists his affiliations: Stantec Australia, where he is a principal scientist, and the University of Western Australia, where he is an adjunct research fellow. The second author's affiliation is listed, too: Woodlands Primary School, where Rehan is in the fifth grade.

IN THE CHILLY WATERS near her home on Vancouver Island, Canada, Krystal Janicki had completed her first 60 scuba dives without ever spotting an octopus. When she finally met her first one, six years ago at the age of 29, she was so frightened that her heavy breathing nearly exhausted her air supply.

Her group was exploring a shipwreck when one diver encountered an adult giant Pacific octopus. The five-foot-long (1.5 m) animal reached out a long, red, suckered limb, then crawled onto the diver's arm, and finally perched on his shoulder. Janicki was horrified at first. "I just thought they were these scary, dangerous creatures," she said. When the group surfaced, she was full of questions—the first of which was, Why was this octopus touching you?

Seeing that octopus reach out to a human, she says, "lit my fire. I wanted to know everything. There was something that sparked with me."

So often, the road leading to scientific breakthroughs begins in a moment of connection. For Sylvia de Souza Medeiros, it happened during a field class in biology, when an octopus began to follow her, changing colors, trying to grab her measuring stick. For Schnell, she was just five, looking for sea stars and shells. She felt something touch her hand—and saw an octopus wrapping its arm around her finger. Since the age of three, Rehan has spent much of his life in the ocean, riding on his dad's back as he snorkeled the reefs near home and falling in love with the creatures around him—especially the octopus who reached out to touch him.

Confronted with an octopus, we are thrilled to meet a creature so different from us. With their three hearts, blue blood, and arms that can hunt even when severed, they seem alien. Yet we are drawn, too, to our shared sameness. Their eyes, so similar to a human's, seek ours; they reach out their

FOLLOWING PAGES: A Maori octopus (*Macroctopus maorum*) encounters an aggregation of spider crabs near Maria Island, Tasmania.

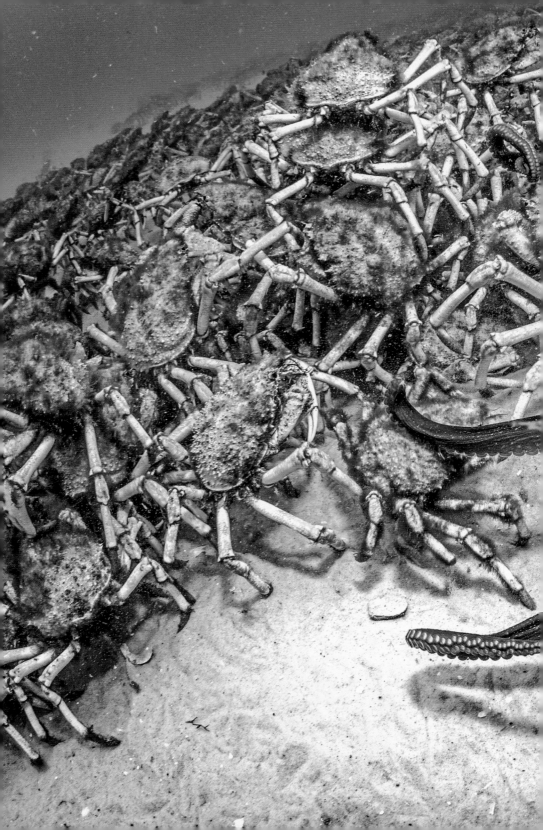

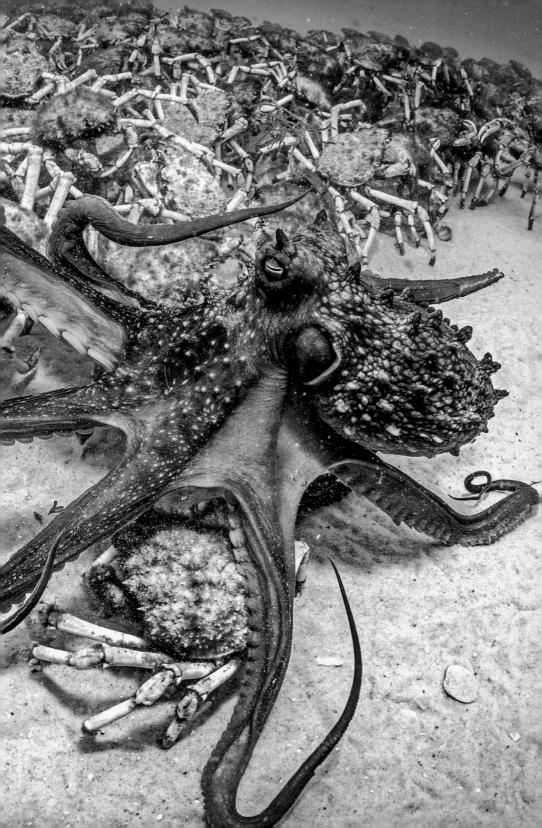

arms toward our own. A human brain and an octopus's brain look very different. But they are capable of many of the same things, from figuring out how to open a jar to recognizing a human face. What else can they do that we do? What else can they do that we can't?

We are on the cusp of finding out so much about this fascinating creature, says Schnell. But to do so, we need to shed the hubris of believing that humans, or mammals, or vertebrates, are the only animals with complex behaviors, with intelligence, with memory, with emotions. "Nobody wants to talk about the elephant in the room—and now we're forced to," she says. "Animals may not have the same experiences humans do, but they are capable of processing information in a way that requires them to think and feel. And it's been shown in animals from magpies to apes to rats to cuttlefish." She hates the term "lesser species"—but feels strongly that even those animals to which we ignorantly assign that moniker "are also able to experience emotions and recollect memories. There's more and more evidence to show that we can't keep ignoring this fact."

We need to shed our arrogance. We need to open ourselves to awe. And we need the humility to welcome different voices. We need to recognize that we can be wrong.

Today, Krystal Janicki seeks out octopuses nearly every day. Tantalizingly, her experiences defy so much of what she had read and believed.

She has seen giant Pacific octopuses walking around on two stiff limbs, like Huffard's algae octopuses. She has seen the supposedly solitary animals living in associations, as do the common Sydney octopuses of Octopolis and Octlantis.

Not far from her house is a 28-foot (8.5 m) sailboat wreck, sunk at a depth of about 70 feet (21 m) and listing on its side. She visits it often. On her first dive there, she and her dive buddy found nine giant Pacific octopuses, each between six and 10 feet (1.8 and 3 m) long, in dens they had dug and siphoned in the sand beneath the sunken boat. The dens were less than

two feet (0.6 m) away from each other. The octopuses had created "an octopus apartment complex," she said. She and her buddy returned seven times, and all the octopuses were still there—including one female with a heart-shaped scar on her mantle. Her den was right underneath the bow of the sunken boat, and on every dive, she would come out to meet the visitors. "We would lay beside her, take off our gloves, and we'd feel her suckers on our hands, wrapping around our hands," Janicki reports. From time to time, they'd feel the octopus flexing her muscles. "Silky Jell-O would turn to powerful muscle in a blink. It was amazing."

Then one day, the special octopus was gone. "We weren't ready to say goodbye," Janicki says. But she still finds octopuses living side by side in their underwater apartment complex. On a recent afternoon, she counted five of them.

"I've always read they were solitary," she says. "But around here, we find handfuls of them on shore dives." South of the island, in just an hour and a half, she and her dive buddy encountered about 20 octopuses at one particular rock formation. "The walls and boulders were like an octo condo!"

Though many octopuses she encounters are shy, quite a number seem surprisingly friendly. She can tell many stories of octopuses who have chosen to leave their dens to play with her. One octopus, which she found in her den, yanked on her hand so hard that Janicki chose to back off, retreating five kicks away to retrieve a camera she had set down earlier. The next thing Janicki knew, the seven-foot-long (2 m) giant Pacific octopus was on top of her—"not sucking or pulling or yanking," she says. "Just *on* me." She thought the embrace would last for seconds. But five minutes later, she was still firmly in the octopus's firm but gentle grip.

"I was face-to-face with her," she remembers. They locked eyes. The octopus's pupils enlarged. The chromatophores in her eyes seemed to flutter, "flashing on and off, getting strong and deep, filling the eye, higher and stronger in depth and color.

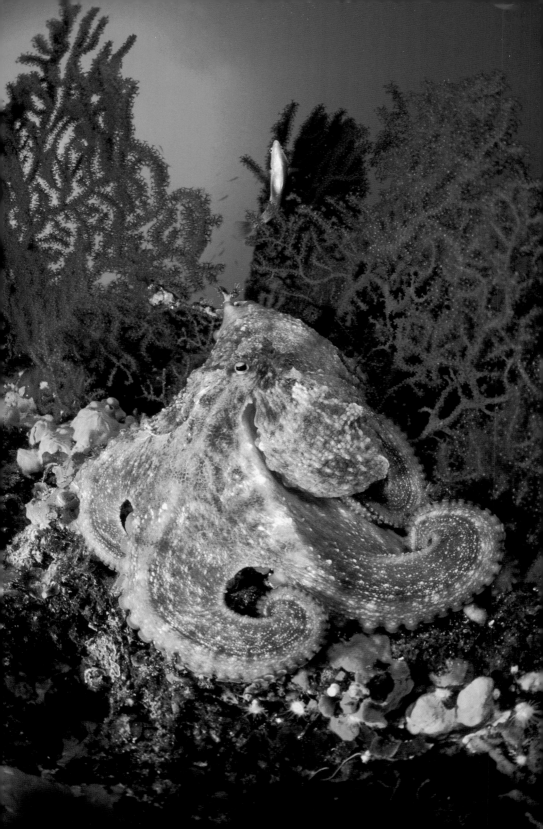

"Her arms were moving over me, my camera, up and over," Janicki continues, dreamily reliving the memory. "And I notice she is breathing out when I am breathing out."

Six or seven minutes went by. Other divers were snapping photos. But Janicki was oblivious to them, lost in the moment. "I forgot everything else existed," she confesses. "One arm is up and over my cheek and holding my head against her mantle. We're completely off the ground. We're floating. She's holding me with two arms. I'm feeling her breathe …"

The sense of communion was palpable as the two adult females—one vertebrate, one invertebrate; one marine, the other terrestrial—stared into each other's eyes across a chasm of half a billion years of evolution. "It stole me in way I've never felt with a human or an animal before," says Janicki. "It was an honor and incredible. I'll never forget how powerful it was."

A common octopus seems to strike a pose in Croatia's colorful coastal reef.

# Expanding Imaginations, Opening Hearts

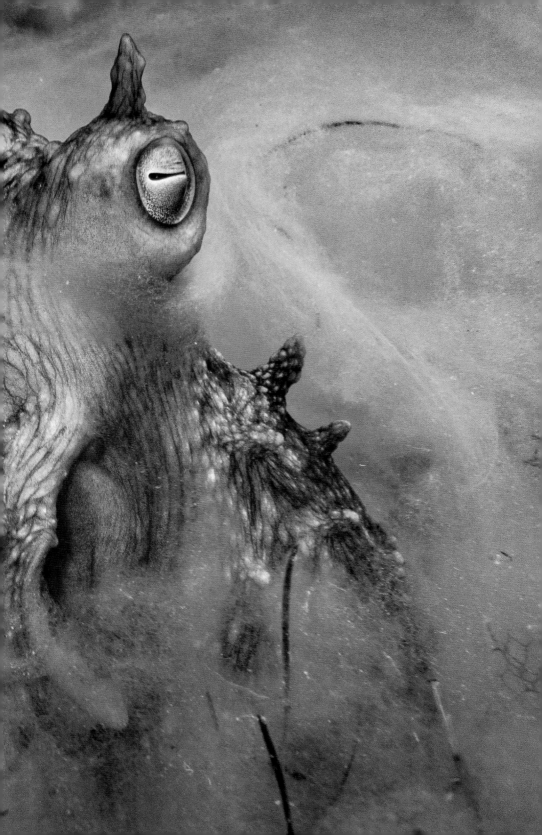

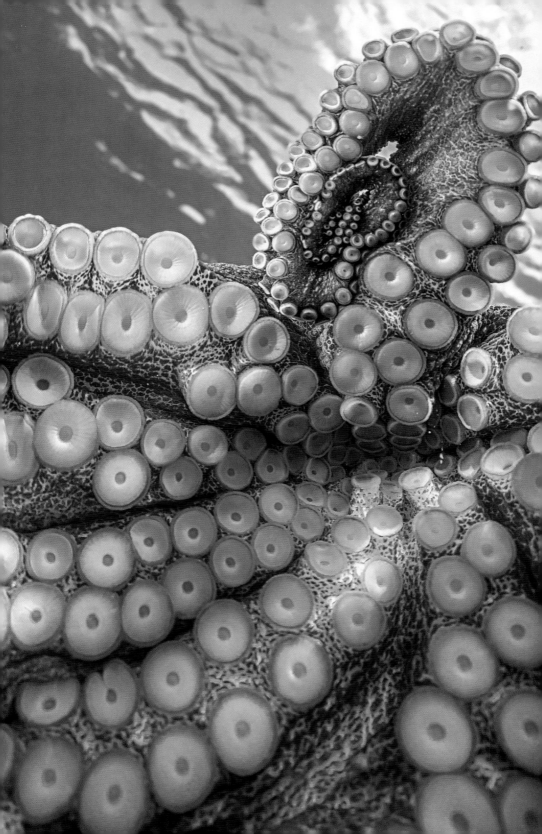

After a day with my octopus friends at the New England Aquarium, I used to drive the whole two hours home singing aloud with joy. Every day I spent in their company was blissful. Some were revelatory.

Early in our friendship, for instance, Octavia—who had been captured as a large, wild adult, and who was wise in the ways of the sea—revealed herself as a trickster. I had invited some friends from the national environmental radio show *Living on Earth* to meet her. The program's host, my friend Steve Curwood, brought a producer and sound crew, and they stood around the tank with Octavia's keeper, Bill Murphy, volunteer Wilson Menashi, and me, enjoying our interactions. We fed Octavia capelin from a bucket. We stroked her skin. She toyed with our hands with her suckers. We were lost in the spectacle of her color changes, the feel of her grasp on our skin, the languid way the webbing between her arms floated like silk in the water. How many minutes went by? We didn't know. But then it occurred to us she might like another fish. On the ledge at the lip of her tank, we searched for the bucket that had held the capelin. It was gone.

Three of us had our hands in her tank with her. Three others were watching her, too. Somehow she had stolen the bucket right out from under our noses.

A search revealed that she was holding it beneath her, hidden by the webbing between her arms. And to our surprise, she wasn't eating the fish.

---

An octopus can regenerate one arm in two to four months.

**PREVIOUS PAGES:** The Maori octopus is one of the largest species native to the waters of New Zealand. Fully extended, its arms can stretch nearly 10 feet (3 m) from tip to tip.

The fish were still in there. She was interested, instead, only in the bucket. Once we discovered this, she let it go, as if now that we had found it, she was bored with her prize.

To Curwood, what had happened was obvious: An octopus had just outsmarted six people. "If an octopus is this smart," he asked on mike, "what other animals are out there that could be this smart—that we don't think of as being sentient and having personality and memories and all these things?"

Another time, it was Kali who surprised us. One of the octopus's most ardent admirers, aquarium volunteer Christa Carceo, wanted to gift her twin brother, Danny, who had pervasive developmental disorder, with a behind-the-scenes visit with Octavia and Kali. Danny read everything he could find about octopuses. He adored them.

But he was also wary. He'd seen a TV show once in which an octopus as big as a building was attacking people, and he wasn't sure if this sort of thing might happen in real life.

So when we opened the top of Kali's tank, Danny was of two minds. Kali's head and three of her arms rose up from the water to meet Christa, Wilson, and me. She attached her suckers firmly to our flesh. Danny wanted to touch her, but he couldn't help it: He was shaking with fear. Each time Danny poked her sucker with a single, trembling finger, she withdrew again and again.

"She won't hurt you!" Wilson promised. "Go ahead! Don't be afraid!" Christa urged. But Danny could not overcome his fear. He kept shaking, and Kali didn't like it.

Suddenly, a gusher of freezing cold salt water arced from the barrel, then another, then another. The third spout hit Danny, and only Danny, squarely in the face.

Another person might have been frightened. Another might have felt offended—and, cold and wet, then walked away. But not Danny. Because of her gusher, he now saw her not as a monster but as a playmate. Now he felt comfortable enough to give Kali his hand.

The octopus gently attached five suckers, then 10, then perhaps 20 to Danny's outstretched palm. "I think she really likes me," he said.

What was going on in Kali's mind? It seemed clear that she perceived Danny was nervous. But how could she tell? Octopuses don't quake with fear as so many mammals do. Could she taste his fear on his fingertips? And what signal did she intend to send with her blasts of salt water? Was she irritated? Or was this her invitation to play? How, and in what way, did she understand that Danny was no longer afraid?

Perhaps someone like Alex Schnell or C. E. O'Brien will one day figure it out. But for us, even as non-scientists, Kali's behavior showed that she recognized each of us as individuals—individuals with differing and changing behaviors and emotions.

THERE WERE MANY DAYS when nothing particularly unusual happened at the aquarium. Except, of course, for the fact that an octopus would see me, recognize me, rise from her hiding place, come to my side—and, as I gently stroked her gelatinous, miraculous body, would hold me gently with her suckers and play with me.

Many other people who come to know octopuses experience this same wonder. In filming the TV series *Secrets of the Octopus,* Adam Geiger recalls working with one particular day octopus he met off Australia's Lizard Island. She was perched atop a boulder-shaped coral head with a crevice that served as a den. "Day one, we'd spend two hours getting close and then moving away, habituating her to our presence," he said. "The octopus would watch us, not moving. Day two, after half an hour, the octopus might swim off to hunt and let us follow. Day three, the octopus would watch us for 10 minutes and then start foraging. Day four, after five minutes, she was

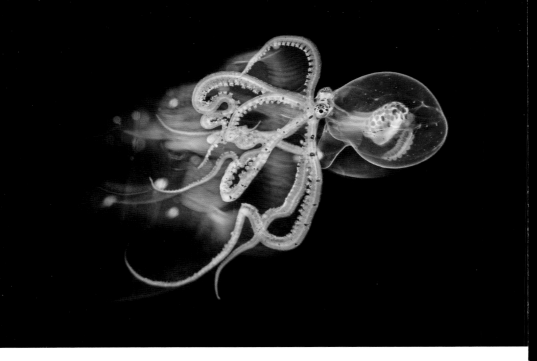

A juvenile wunderpus drifts off the coast of the Philippines.

perfectly comfortable with our presence." That was special enough. It showed that this octopus was a quick study. It normally takes field biologists months to habituate their study animals to their presence. But what stuck with Geiger, who has spent a lifetime filming wild animals, was that "this one animal, in particular, seemed to recognize and feel most comfortable with me. It seemed to me she would drop by closer to me, and even touch me—more so than the other cameramen." This, he said, was "an incredible privilege."

True, the same can be said for any animal who allows you into its life. I love any time I spend with any animal: Walking our dog. Watching a turtle at the pond. Enjoying falconry with a hawk.

But communing with someone as different from us as an octopus is thrilling and mysterious. It feels almost magical. Perhaps it is because of their ability to change color and shape. Humans are drawn to tales of trans-

formation. The Scotch and Irish have tales of selkies, seals who can shape-shift into the body of a human. In the Amazon, river people tell stories of pink dolphins they call *encantados,* enchanted beings who may show up at dances as beautiful strangers, seduce men and women, and then dive back into the water and return to their dolphin form. The Norse warrior gangs known as berserkers were said to be such effective fighters thanks to their ability to change into wolves and bears. In Slavic mythology, the god Veles, ruler of magic, animals, and the underworld, could appear in the form of a wolf, snake, owl, or dragon. In all these stories, these shape-shifting creatures bring to us mere mortals knowledge of other worlds.

These are, of course, myths, not science. But over and over, as seen in the stories and data and film footage reported in this book, today—thanks in part to technologies of which ancient humans could never have dreamed—the shape-shifting octopuses are, in fact, doing precisely this. They are showing us other worlds—worlds that overlap with our own but are outside our sphere of experience.

The new findings researchers are now reporting about octopuses' minds and bodies have deepened my understanding of my relationships with the octopuses I have known through the years. I now have an idea why these octopuses may have wanted to spend time with me in the first place: It's now known that octopuses aren't all loners. Some species, at least under certain circumstances, can thrive in the company of others. Maybe making friends with me was not simply an aberration due to their captivity.

And another reason all this new science excites me is because, it seems, this latest research increasingly reveals the truths embedded in the ancient stories: that, as different as we are, we are all connected, and the connections between us and the rest of animate creation run deep.

We need to be reminded of this from time to time. I still visit the aquarium, and now, as then, I sometimes like to stand back and watch the public look at the octopus on display and listen to their thoughts. One day, three

teenage girls came upon Octavia. "Ew!" said one girl, "I bet it feels gross if you touch it!" I couldn't help but speak up on behalf of my friend.

"But look," I interjected, "did you see her eggs?"

They had not. Earlier, Octavia, now approaching the end of her life, had laid tens of thousands of rice-grain-size white eggs. At night, unseen by any of us, she produced more and more strands of eggs, which she cemented with a secretion from a gland in her head so they hung like strings of pearls from the ceiling and walls of her lair. The eggs were infertile, alas, because there was no male octopus to fertilize them. But Octavia could not know that—so, as would a mother octopus in the wild, she guarded and cleaned them assiduously. Should specks of detritus land on her pearly treasures, she shot water from her funnel to hose them clean. With her dexterous suckers, she stroked and fluffed each strand. She never left her eggs, not even to eat. No longer did she rise to the top of the tank to play with us and accept fish from our hands—now we had to hold food out to her in her lair on a long metal grabber.

"There are thousands of eggs," I told the girls. "And she is taking such good care of them all." I pointed out how she was frilling her suckers to touch each strand, like you might kiss a baby.

The change in these young visitors' attitude was instant. "No way!" said the girl who had just called Octavia "gross." "Way cool!" enthused one of her companions. The three stayed at Octavia's tank watching in awe for several minutes, and all took pictures of her with their cell phones before they moved on. As the trio turned to leave, one of them said to me tenderly, "Take care of that little mom."

How I wanted to care for my friend at that vulnerable and intimate moment toward the end of her too-brief life! But other than hand her some fish on the grabber, there was little we could do for Octavia. She did not want to interact with us anymore. She had more important things to do: She had to attend to her eggs. Wild giant Pacific octopuses are such devoted mothers that, from the moment they start laying, they never leave their lair,

not even to eat. A wild mother octopus starves herself for the entire six months her eggs are incubating, and she may use her last breaths to blow, from her siphon, her hatching paralarvae out from their nest and into the wild, open ocean.

Octavia's unfertilized eggs would never hatch. But still, she never left them. For five months, then six months, then seven. Despite her devotions, the eggs began to fall from the ceiling, to shrink and decompose. Still she stayed plastered atop those that remained. Eight months, nine months, then 10.

Meanwhile, our friend was growing old. Despite our feeding her, with advancing age, her strength ebbed. Her skin was sloughing. Her colors muted. She looked tired and small.

Then, one morning I noticed one of her eyes was swollen. She had an infection. As happens to all of us, with increasing age, her body was failing. Her keeper, senior aquarist Bill Murphy, decided it would be best for her to move her off exhibit, so she could spend her last days in quiet darkness, as a dying mother octopus would in the wild.

After she had been moved, I came to see her, to say goodbye. I did not expect her to recognize me. Giant Pacific octopuses live only three to five years, and for 10 months of that short life, because of her preoccupation with her eggs, she had not tasted my skin or looked up at my face at the surface of the water. For an octopus, 10 months apart is the equivalent of decades of separation.

Researchers have known a few animals to recognize, and warmly greet, people who were important to them in their early lives. Christian the lion had been raised by two young men. They brought her to Africa in 1971 to live in the wild. Nine months later, the men came to visit. Christian ran ecstatically to greet them and rubbed her chin against their faces. Kwibi the gorilla had been born at an English breeding facility for later release into the wild. Five years after his release in Gabon, his former caretaker, Damien Aspinall, went to visit him. Even though they had been apart for half of Kwibi's life, the gorilla greeted his friend with sniffs, nose rubs, and hugs—and then

introduced the man to his gorilla family. But lions and gorillas are big-brained mammals like ourselves. Would Octavia even remember me?

Wilson unscrewed the lid to her tank as we leaned over and looked inside. We could see Octavia on the bottom. She was old and sick and dying. But even so, to our surprise, almost immediately she rose to the top. She looked into our faces. She offered us her suckers.

We handed her a fish, but she dropped it to the bottom. She wasn't interested in eating. Instead—even though this might have been quite an effort—she remained at the top of the tank with us for many minutes, holding us and tasting us as we stroked her silky skin one last time.

Octavia died not long after that, and I wrote about our last encounter in my book. Few might have believed that the life and death of a short-lived invertebrate animal would bring hundreds of thousands of readers around the world to tears—but it did. Her life mattered.

Jane Goodall made a similar point in an article she wrote for the *Sunday Times* of London that ran October 1, 1972. In it, Goodall commemorated the life of a chimp named Flo, the highest-ranking female in her community. Goodall had been following and writing about Flo ever since the scientist first arrived at Gombe in 1960. "Flo has contributed much to science. She and her large family provided a wealth of information about chimpanzee behavior," Goodall wrote. "But even if no one had studied the chimpanzees of Gombe, Flo's life, rich and full of vigor and love, would still have had a meaning in the significance and pattern of things."

This is surely true of Octavia as well—and of every animal, captive and wild, be they in a lab, a public aquarium, or the ocean. It is my hope that we can use our scientific findings about their lives not only to enhance human knowledge, as valuable as that is, but also to honor who these animals are—individuals as intensely wedded to this glorious life as we are, whose lives are as meaningful and significant, in their way, as our own.

# Octoprofiles

## WARREN K. CARLYLE IV

Octopuses display some of the most astounding and peculiar diversity of any animal in the ocean world. There are more than 300 individual species of octopus worldwide, and as octopuses gain more focus and attention from researchers, new species come to light with increasing regularity. Some are bold. Some are shy. Some are sleek. One—as you'll see here—is hairy. These 16 profiles showcase a few of the most wondrous octopuses (and cuttlefish) known to humans. For all their majesty, they represent just a small sample of the ocean's boundless mysteries. There is so much more about these glorious creatures left to discover.

# Common Octopus

## *Octopus vulgaris*

**LIFE SPAN:** 12–15 months

**SIZE:** 4 feet (1.3 m)

**WEIGHT:** 22 pounds (10 kg)

**RANGE:** Tropical, subtropical, and temperate seas worldwide

**DIET:** Crabs, bivalves, gastropods, polychaetes, other crustaceans, cephalopods, various species of bony fish

**SIZE RELATIVE TO A 6-FT HUMAN:**

The common octopus inhabits warm waters around the world—and that ubiquity earned it its rather demeaning species name, *vulgaris,* or common. Its behavior alone shows it deserves better nomenclature.

The common octopus is a savvy problem solver. It can probe hidden crevices in the reef or use its webbing to trap and envelop prey. It can also squirt water out of its siphon to blast sediment off coral heads or out of shells and crevices, revealing hidden treats. It can use its powerful arms and suckers to pry open a mollusk, or use its radula—a sharp tonguelike structure inside its beak—to drill through a mollusk's shell and scrape out food. The radula can also sweep surfaces or inject a paralyzing toxin into its prey.

Seals, barracudas, and eels prey on the common octopus, but this cephalopod has numerous defenses. It can blend into its environment thanks to olfactory camouflage, whereby the octopus generates a scent typical of a less tasty organism to confuse a predator, and squirt dark ink out through its siphon. In an actual confrontation, the common octopus might flail its arms to frighten the predator away.

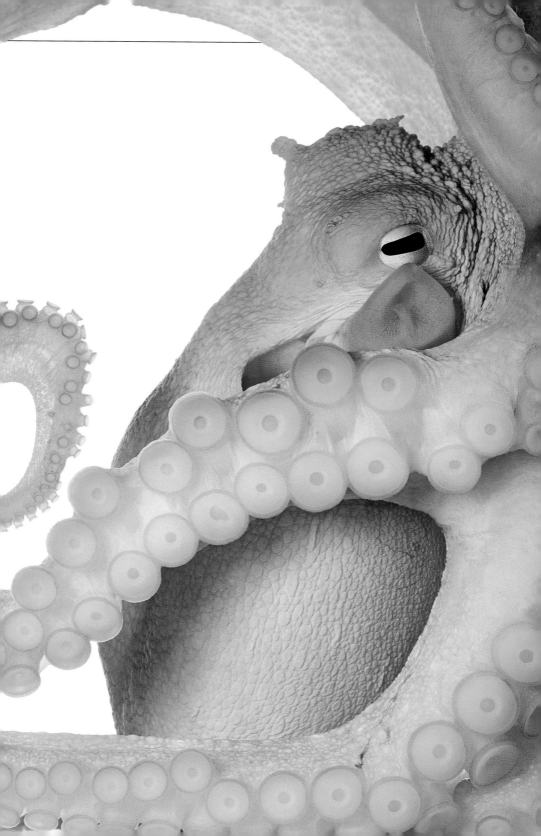

## OCTOPROFILE

# Wunderpus

## *Wunderpus photogenicus*

**LIFE SPAN:** Unknown

**SIZE:** 16 inches (40.6 cm)

**WEIGHT:** .24–.38 ounces (7–11 g)

**RANGE:** Tropical southwestern Pacific Ocean

**DIET:** Small crustaceans, fish

**SIZE RELATIVE TO A HUMAN HAND:**

Hidden in a world of sand, mud, and rubble, the wunderpus's distinctive candy-cane pattern and tall eye stalks give it a mesmerizing presence. This extraordinary creature has a strong connection to its habitat, preferring soft sediment substrates where it can burrow deep into the sand, creating a sanctuary where it can rest and hide. Many other octopus species are nomadic, but the wunderpus remains loyal to its home: It has been known to occupy the same burrow for at least three weeks at a time. From this domain, it gracefully extends its long, flat arms, probing the crevices and burrows of the seafloor for unsuspecting prey.

Living up to its species name, the wunderpus is gloriously photogenic, its body a living mosaic of golden hues and intricate designs. Its eye stalks stand erect and at the ready above its Y-shaped head. Candy-cane stripes adorn its webbed arms, which can extend five to seven times the length of its mantle, which

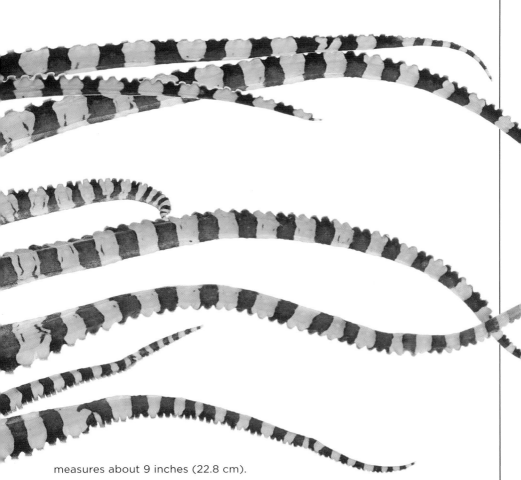

measures about 9 inches (22.8 cm).

When a small fish or crab ventures close, the wunderpus lifts up on its arms as if standing to position itself above its target. Then, in one swift motion, it expands the web between its arms to create a parachute-like trap that envelops its prey. With a swift pull of an arm, it draws the prey to its beak, injecting it with a paralyzing cephalotoxin, a saliva-based toxin unique to certain cephalopods, including the wunderpus. In the most threatening of situations, this octopus can detach any of its long arms, leaving them behind with its pursuer and then regenerating them once it has returned to safety.

The wunderpus can also twist and contort its arms into confusing shapes that confound predators. It can flatten its body and morph its skin to mimic a flounder on the ocean floor, spiral its arms to emulate the twisting coils of a sea snake, or undulate its body to imitate the pulsing motion of a jelly—all talents worthy of its name.

# Caribbean Dwarf Octopus

## *Octopus mercatoris*

**LIFE SPAN:** 8–10 months

**SIZE:** 4.5 inches (11.43 cm)

**WEIGHT:** 1 ounce (28.3 g)

**RANGE:** Caribbean Sea, Gulf of Mexico, shallow Florida coastal waters

**DIET:** Crabs, shrimps, small fish

**SIZE RELATIVE TO A HUMAN HAND:**

The Caribbean dwarf octopus is a marble-size wonder native to the Caribbean Sea and nearby tropical and subtropical waters. It favors shallow seagrass beds no deeper than 16 feet (5 m), prime real estate for hiding from predators and snorkelers alike. While it inhabits waters close to land and favored by swimmers and divers, little is known about this tiny octopus species.

Cloaked in hues of dark brown and red, the Caribbean dwarf octopus finds its best camouflage in a nocturnal environment. These octopuses are agile predators despite their size, known to stalk small fish, crabs, and shrimp, striking their prey with astonishing precision. Larger marine species likewise see them as prey, but these octopuses maintain a potent defense mechanism: They can eject a thick cloud of ink, disorienting would-be

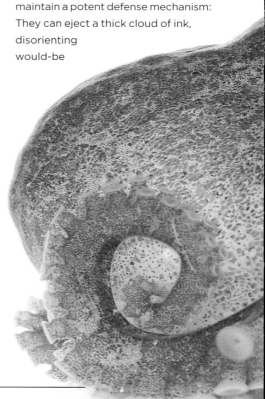

156

predators while making a swift getaway.

While octopuses have long been considered to model a solitary existence, small congregations of Caribbean dwarf octopuses have occasionally been observed among rocks in shallow waters. The details of their social lives are still a mystery, though, and scientists are trying to understand how and why octopus communities originate and function.

Although they're among the smallest known octopus species, the Caribbean dwarf octopus boasts a remarkable reproductive capacity. Females can lay between 50 and 320 large eggs per brood, from which emerge young that prowl the ocean floor, ready to navigate and hunt immediately. These large eggs make this species a favorite in the pet octopus trade—a small but dedicated population of aquarium owners and cephalopod boosters.

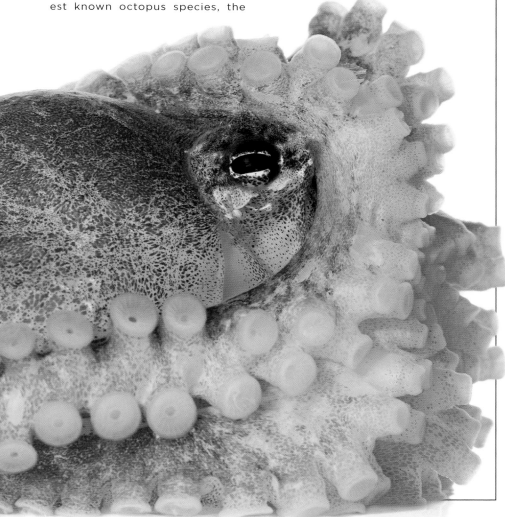

# Coconut Octopus

*Amphioctopus marginatus*

**LIFE SPAN:** 1–2 years

**SIZE:** 12 inches (30 cm)

**WEIGHT:** 1 pound (.45 kg)

**RANGE:** Tropical Indian and western Pacific Oceans

**DIET:** Crabs, clams, fish, shrimp

**SIZE RELATIVE TO A HUMAN HAND:**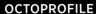

The coconut octopus, also known as the veined octopus, displays its vascular system all over its skin. Dark purple veins emanate from the top of its head like those of a big-brained supervillain and cascade all the way down the octopus's arms. They betray this animal's surprising cognitive sophistication. The coconut octopus scavenges and uses tools for hunting and hiding.

Other octopus species have been observed to move, lift, and carry rocks to barricade their lairs. But the coconut octopus works with diverse materials, taking its abilities outside its den and using objects for various purposes. These octopuses use empty coconut shells or clamshells to build portable shelters. A coconut octopus will clutch such an object from above using six of its arms, while the remaining two arms "walk" on tiptoe across the ocean bottom. To the onlooker, it appears as if the shell is on stilts.

Likewise, a coconut octopus might approach an abandoned clamshell, curl up inside it, and use its suckers to pull the halves together, creating a hideaway on the ocean floor. Coconut octopuses have been found to use all sorts of ocean-floor refuse—even broken glass bottles—to create protective shelters for themselves. A female can use this item as a den to rest and lay her eggs in peace.

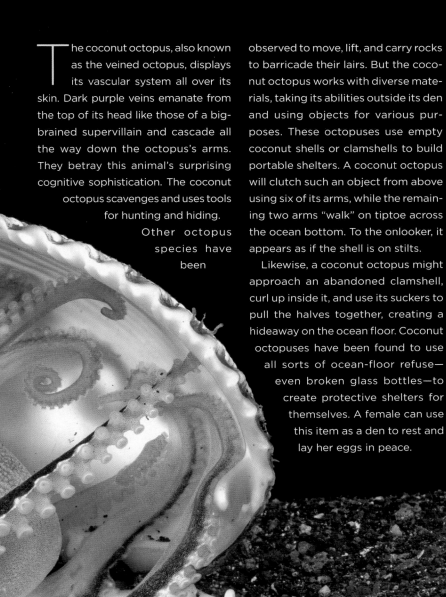

# Giant Pacific Octopus

## *Enteroctopus dofleini*

**LIFE SPAN:** 3–5 years

**SIZE:** 9–16 feet (2.7–4.8 m)

**WEIGHT:** 156 pounds (71 kg)

**RANGE:** Coastal areas of the northern Pacific Ocean

**DIET:** Crustaceans, bivalves, echinoderms, brachiopods, shark eggs, seabirds (rarely)

**SIZE RELATIVE TO A 6-FT HUMAN:**

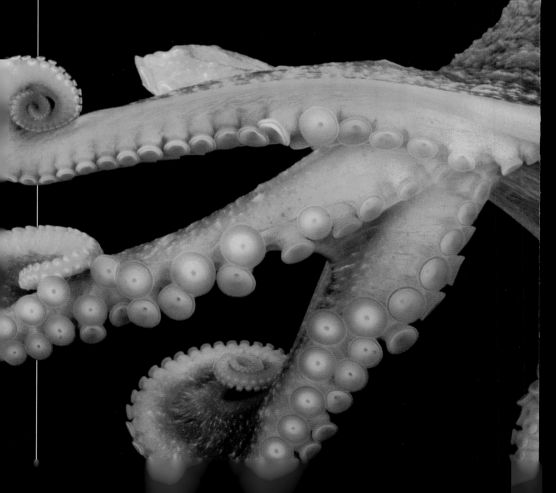

The giant Pacific octopus is the largest octopus species in the world, and it has the brains to match.

A 2010 study conducted by the Seattle Aquarium revealed that these brainy invertebrates could form social bonds with their keepers. The researchers exposed eight octopuses to two different human groups over a two-week period. One human group consistently fed the octopuses, whereas the other touched them with a bristly stick. At the end of the two weeks, the researchers found that the octopuses were more likely to approach and interact with the humans who had fed them, and they seemed to exhibit more relaxed behaviors around them, such as resting and playing, compared with the humans who merely poked at them instead.

But food motivation isn't always necessary to stimulate the nine brains of a giant Pacific octopus. Several captive specimens of this species have demonstrated the ability to use tools, solve puzzles, and enjoy pure play. Researchers have observed the giant Pacific octopus opening jars, twisting Rubik's cubes, and waving, tugging, or siphoning toys around their enclosures, seemingly just for fun. Just like people, though, they seem to lose interest in repeating these tasks. They get bored doing the same thing for a long time.

# Day Octopus

## *Octopus cyanea*

**LIFE SPAN:** 12–15 months

**SIZE:** 3 feet (1 m)

**WEIGHT:** 13 pounds (5.9 kg)

**RANGE:** Tropical Pacific and Indian Oceans

**DIET:** Shellfish, mostly crabs

**SIZE RELATIVE TO A 6-FT HUMAN:**

The extraordinary day octopus uses cunning tactics and strategic alliances to thrive in the dynamic and competitive world of the coral reef. Predators like snappers and barracuda hunt for the octopus as it weaves through the reef's labyrinth of nooks and crannies, but the octopus has several tricks tucked away inside its swirl of arms.

The day octopus can transform from the subtlest shade of beige to a vivid maroon, but if something higher on the food chain sees through its disguise, the octopus can deploy its false-eye spots, or ocelli. The octopus spreads its arms and expands its body, and with the ocelli, it resembles a dangerous predator. The transfor-

mation itself might intimidate aggressors long enough for the octopus to escape.

Day octopuses appear to be able to use spatial reasoning to navigate, which helps them understand and remember the layout of their surroundings. In the lab, researchers have tested this ability by placing plastic markers near food rewards in a tank and then moving the markers. They found the octopuses would go to the markers even when they were relocated. These observations suggest that in addition to using chemotactile information—input from an animal's arm suckers, taste, or sense of touch—to explore their environment, day octopuses also use visual landmarks such as rocks, coral formations, and other noticeable features.

Despite its impressive individual capabilities, the day octopus may team up with helpful fish, such as the lyretail grouper, to hunt. The grouper can spot prey more than 100 feet (30 m) away, and it has been seen communicating the prey's location to the octopus through what researchers call "subtle headshakes." In return, the octopus can access prey tucked away in narrow crevices and flush it out so both species can partake.

Opportunistic thieves like the tailspot squirrelfish might linger near this partnership, waiting to snatch a free meal from the octopus's grasp. But the day octopus has an "octopunch" that it uses to fend off moochers, thrashing its arm with a whiplike motion and shoving any marauding fish out of the way.

# Blue-Ringed Octopus

## *Hapalochlaena lunulata*

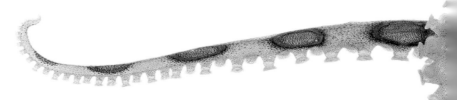

**LIFE SPAN:** 2 years

**SIZE:** 8 inches (20 cm)

**WEIGHT:** 3.53 ounces (100 g)

**RANGE:** Southwest Pacific Ocean, eastern Indian Ocean

**DIET:** Mostly crustaceans

**SIZE RELATIVE TO A HUMAN HAND:**

The blue-ringed octopus, no larger than the span of a human hand, hides a deadly secret in its beak: a potent neurotoxin called tetrodotoxin (TTX), produced by symbiotic bacteria living in its posterior salivary glands and injected through its beak.

TTX disrupts nerve cell functionality, blocking its sodium channels and leading to paralysis within seconds. The blue-ringed octopus's bite might feel painless, but just one milligram of TTX can be lethal to humans. Humans affected by TTX have reported burning or tingling sensations, numbness, muscular weakness, vision changes, and difficulty speaking. Severe cases have led to paralysis and respiratory failure, and there's no known antidote. Thankfully, these creatures are not aggressive toward humans and pose no threat unless provoked or mishandled.

But when a threat approaches, the blue-ringed octopus is ready. In less than a second, it can transform its brown body into a bright yellow canvas, pockmarked by up to 60 iridescent blue rings scattered on its skin. A halo of dark chromatophores encircles each ring, turning the octopus's skin into a confounding pattern, a signal deterring any other species from approaching and risking exposure to its vicious bite.

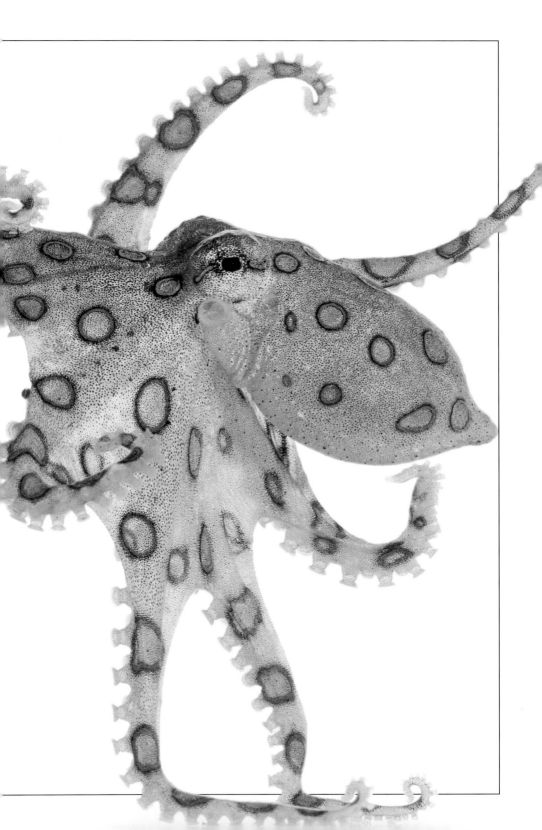

# Blanket Octopus

*Tremoctopus* sp.

**LIFE SPAN:** 3–5 years

**SIZE:** 39 inches
(99 cm)

**WEIGHT:** 22 pounds (10 kg)

**RANGE:** Tropical and subtropical oceans
around the world

**DIET:** Small mollusks, fish, jellies

**SIZE RELATIVE
TO A 6-FT HUMAN:**

The female blanket octopus (pictured) lives a nomadic life. As she glides through the ocean, her cape—a flowing, transparent expanse of flesh connecting four of her arms—ripples like a celestial gown. When the sun shines, the cape projects a kaleidoscope of colors, transforming the octopus into a living, breathing rainbow.

But the open ocean is fraught with danger for the female. Large open-water predators such as tuna, sailfish, and sharks find her a delicacy. The female blanket octopus turns out to be a formidable foe, however. By unfurling her magnificent cape and displaying its striking eye spots, she can intimidate those who approach her. In the event that her grandeur is not enough to deter a predator, she can deliberately shed portions of her cape along visible fracture lines to leave a bewildering distraction in her wake. And if she has to fight, she can demonstrate fierce

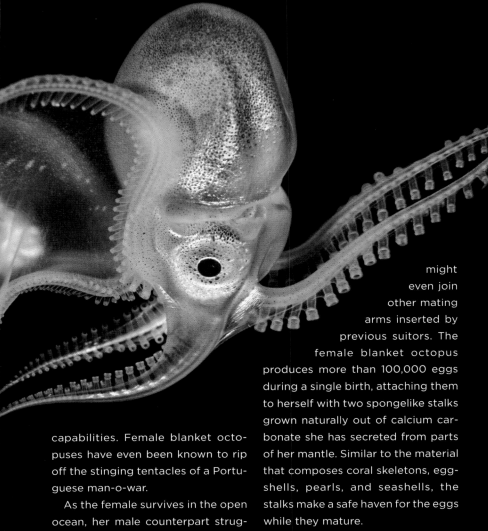

capabilities. Female blanket octopuses have even been known to rip off the stinging tentacles of a Portuguese man-o-war.

As the female survives in the open ocean, her male counterpart struggles to find her. He's small—no larger than a strawberry—but determined. After instinct guides him to his mate, he detaches his mating arm with its cargo of spermatophores and offers it to her. While this act will kill him, it's his best shot at ensuring the continuation of the species.

The mating arm, once detached, wiggles deep into the female's mantle to accomplish fertilization. It might even join other mating arms inserted by previous suitors. The female blanket octopus produces more than 100,000 eggs during a single birth, attaching them to herself with two spongelike stalks grown naturally out of calcium carbonate she has secreted from parts of her mantle. Similar to the material that composes coral skeletons, eggshells, pearls, and seashells, the stalks make a safe haven for the eggs while they mature.

The eggs assume a sequence of colors as they progress through each developmental stage. They gleam white early on; more developed embryos turn pink; and the most advanced embryos take on a dark gray shade. As a mother blanket octopus journeys through the open ocean, she uses her cape to protect her eggs, keeping her brood close to ensure their survival.

# Flamboyant Cuttlefish

## *Metasepia pfefferi*

**LIFE SPAN:** 1–2 years

**SIZE:** 4–5 inches (10–13 cm)

**WEIGHT:** 1.5 ounces (42.5 g)

**RANGE:** Tropical Indo-Pacific waters

**DIET:** Fish, crustaceans

**SIZE RELATIVE
TO A HUMAN HAND:**

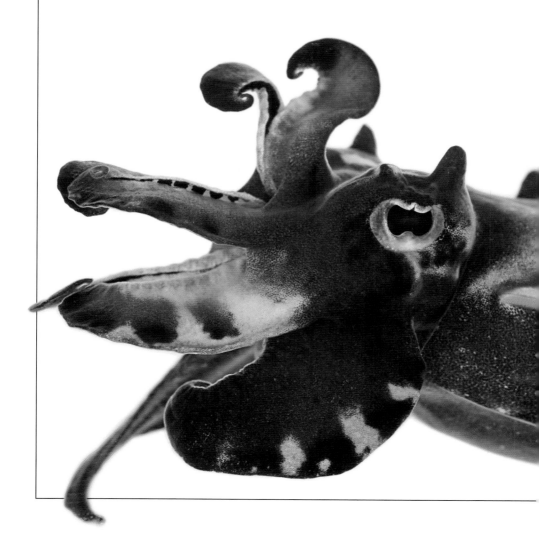

lamboyant cuttlefish, closely related to octopuses, spend most of their days camouflaged against the sandy Indo-Pacific seafloor, resembling little more than a pile of mud. With more color-changing cells per square inch than any other cephalopod, their skill in remaining incognito is unparalleled.

Though this solitary species traverses the underwater desert between coral reefs, it isn't an efficient cruiser. Its diamond-shaped cuttlebone—a torpedo-shaped internal shell that spans the length of its body and helps control buoyancy—makes gliding difficult. Instead, the plump, rainbow-hued cuttlefish propels itself with its front arms and pair of hind lobe projections under its mantle: a marine mode of power walking.

But within seven-tenths of a second, the flamboyant cuttlefish can transform from a drab lump of sand to a dazzling spectacle of color and motion. Thanks to fast neural connections among its color-changing chromatophore organs, it can display an entrancing kaleidoscope of colors—white, yellow, red, and brown—creating patterns to bewilder predators or court potential mates, and earning the cuttlefish its common name: "flamboyant."

Male flamboyant cuttlefish are enchanting during courtship. They turn ghostly white with pink arm tips as they vibrate and bob before a female to win her approval. These displays, however, come with a price: an increased risk of attracting attention from predators.

The flamboyant cuttlefish observes and learns how to survive in the ocean before hatching. Flamboyant cuttlefish embryos, encased in transparent eggs, engage in what is called embryonic learning, gathering valuable information about their environment while their eyes develop. For example, unborn cuttlefish can develop a visual preference for a certain kind of prey if they see that prey occurring often outside the confines of their egg. When they're born, the baby cuttlefish already understand which kinds of food are abundant in their area, and which might be more scarce.

# Caribbean Reef Octopus

## *Octopus briareus*

**LIFE SPAN:** 10–12 months

**SIZE (OF FEMALE):** 24 inches (61 cm) from arm tip to arm tip

**WEIGHT (OF FEMALE):** 2–3 pounds (1–1.5 kg)

**RANGE:** Shallow coral reef habitats in the Caribbean, south Florida, and northern South America

**DIET:** Crustaceans, fish, bivalves, worms

**SIZE RELATIVE TO A HUMAN HAND:**

The Caribbean reef octopus spends its days hiding in shallow-water reefs. This nimble cephalopod is a master of disguise, able to blend seamlessly into its surroundings due to kaleidoscopic skin that can mimic the hues of corals, rocks, and seagrass—from bright orange and pink to marbled brown.

At night, the Caribbean reef octopus leaves its den to hunt, pouring its boneless body through coral mazes, and contorting and twisting through its environment in search of prey such as worms and crabs.

When they reach their hunting grounds, Caribbean reef octopuses cast their webbing out like a parachute, engulfing small coral heads and trapping unsuspecting prey. Next, using the tips of their arms like a fine-tooth comb, they poke and prod every crevice for worms and crustaceans. Once the octopus extracts a delectable specimen from a hiding spot, it can use its powerful suckers as a conveyor belt to move the food to its beak.

Like a Chinese finger trap, the suckers are resistant to sheer force, which helps them hold on tight. Octopuses can latch on to attackers to avoid being eaten, or cling to slippery prey.

# Argonaut Octopus (Paper Nautilus)

*Argonauta argo*

**LIFE SPAN:** Unknown

**SIZE:** 17 inches (43 cm)

**WEIGHT:** 1.06 ounces (30 g)

**RANGE:** Tropical and subtropical oceans worldwide

**DIET:** Jellies, salps, crustaceans

**SIZE RELATIVE TO A HUMAN HAND:**

The female argonaut octopus drifts through the ocean using an ingenious trick: When tucked inside her delicate shell, she rises to the water's surface and rocks herself back and forth to collect bubbles of fresh air. By adjusting the amount of air trapped in her shell, she can control her buoyancy and keep herself weightless in the open ocean, conserving energy and giving her control over her movements.

Within hours of hatching, female argonauts start to produce a thin casing using two paddle-shaped arm membranes to secrete calcite and construct delicate spiral structures around their bodies. The resulting construction serves them well as a buoyancy regulator and portable nursery for their eggs.

The male argonaut octopus does not build a shell. He measures only one inch (2.5 cm) in length compared to the female's 17 (43 cm), and yet he demonstrates an equally canny survival skill. He finds refuge inside gelatinous

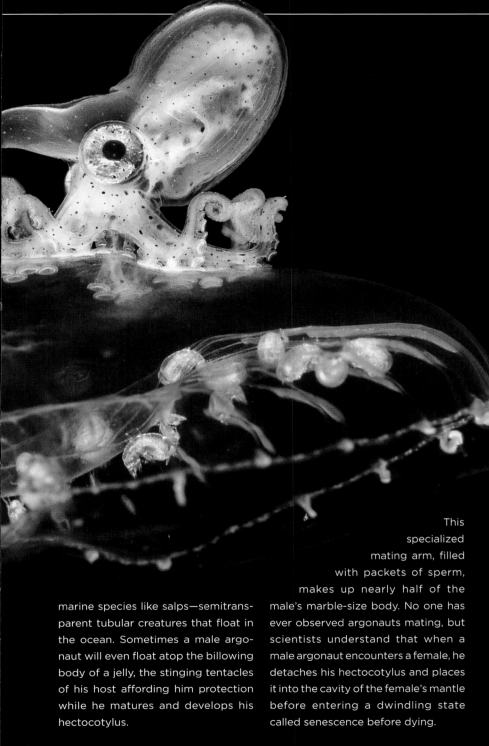

This specialized mating arm, filled with packets of sperm, makes up nearly half of the male's marble-size body. No one has ever observed argonauts mating, but scientists understand that when a male argonaut encounters a female, he detaches his hectocotylus and places it into the cavity of the female's mantle before entering a dwindling state called senescence before dying.

marine species like salps—semitransparent tubular creatures that float in the ocean. Sometimes a male argonaut will even float atop the billowing body of a jelly, the stinging tentacles of his host affording him protection while he matures and develops his hectocotylus.

# Hairy Octopus

*Scientific name yet to be officially described*

**LIFE SPAN:** Unknown

**SIZE:** 2 inches (5 cm)

**WEIGHT:** .17 ounces (5 g)

**RANGE:** Shallow coral reef habitats in the Caribbean, south Florida, and northern South America

**DIET:** Crustaceans, fish, bivalves, worms

**SIZE RELATIVE TO A HUMAN HAND:**

The tiny, peculiar hairy octopus resides amid the muck of fine rubble, small shells, rocks, and broken coral that scatters the seabed. Covered with delicate hairs called papillae, its body sways with the ebb and flow of ocean currents. At just two inches (5 cm) long, this fuzzy critter is a pro at seamlessly merging with its environment.

The hairy octopus moves through the water by riding the ocean's surging currents. It waits for the current to pull in the desired direction before hitching a ride and gliding to the next location. It can use its siphon to propel itself through the water, too, but the stealthier, current-powered approach conserves energy and maintains the octopus's camouflage. It appears to be nothing more than a bundle of plant matter, an ocean tumbleweed. With its cha-meleonic ability to change colors from white to cream, brown to red, and all shades in between, the hairy octopus is a master at camouflage, often nearly indistinguishable from a tuft of algae floating on the ocean floor.

Hypnotic white flashes radiate around the eyes of the hairy octopus—distinctive but as yet unexplained by science. Perhaps this captivating display serves a dual purpose, both as a tactic to intimidate predators and as an effect to stun unsuspecting prey.

Given that the hairy octopus is a relatively recent discovery among cephalopod species, there is still much to uncover about its biology and behavior. This paperclip-size creature reminds us of the vast unknowns within the ocean and the importance of continued exploration to better understand the fascinating creatures that inhabit our planet.

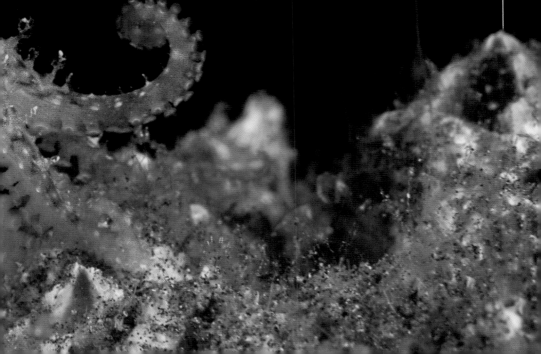

# Common Cuttlefish

## *Sepia officinalis*

**LIFE SPAN:** 1–2 years

**SIZE:** 19 inches (48 cm)

**WEIGHT:** 4–8 pounds (1.8–3.6 kg)

**RANGE:** Mediterranean Sea, North Sea, Baltic Sea

**DIET:** Crabs, shrimp, snails, clams, fish, other cuttlefish

**SIZE RELATIVE TO A HUMAN HAND:**

The captivating common cuttlefish hides remarkable mechanisms beneath its camouflaged exterior of cryptic zebra stripes. Its body is a marvel of nature centered on its cuttlebone—an internal gas-filled structure that the animal uses to control its buoyancy, hovering or diving at will and with precision.

The cuttlebone's porous structure is able to withstand tremendous pressure—about 20 standard atmospheres, or 294 pounds per square inch (2,027 kPa)—yet still resist fracture. Its properties are the envy of human engineers, who see the cuttlebone as an ideal combination of the lightness found in metallic foams and the strength found in ceramic foams.

In a cuttlefish, the bone can take on or release liquid, thus varying its body density. When it becomes denser than seawater, the creature can dive with ease; when it is less dense, the creature floats up. When

the creature seeks to hover, it can regulate its density to reach equilibrium with the seawater at the desired depth.

The common cuttlefish hunts with two long, retractable tentacles in addition to its eight arms, giving it speed and agility. As it searches for crustaceans and small fish to eat, its skin shifts colors and textures: a living canvas of chromatophores, leucophores, and iridophores that allow it to communicate with other cuttlefish during peaceful moments and camouflage itself when threat-ened. In survival situations, it might release a burst of ink to make an escape.

During mating season, males and females engage in an intricate dance of color and gesture before the male transfers his sperm to the female using a specialized arm. After fertilization, the female deposits dime-size, ink-black eggs on the seafloor. Thanks to embryonic learning, the baby cuttlefish hatch with prerequisite knowledge of their environment, ready to embark on their own journey through the underwater world.

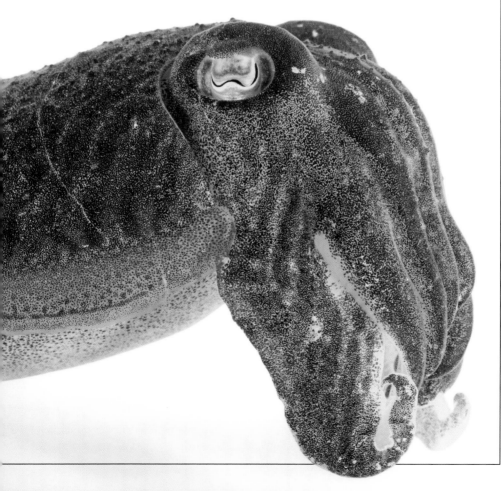

# California Two-Spot Octopus

## *Octopus bimaculoides*

**LIFE SPAN:** 2 years

**SIZE:** 23 inches (58.4 cm)

**WEIGHT:** 2 pounds (.91 kg)

**RANGE:** Coastal waters of California and Baja California

**DIET:** Limpets, black abalone, snails, clams, hermit crabs, small fish

**SIZE RELATIVE TO A HUMAN HAND:**

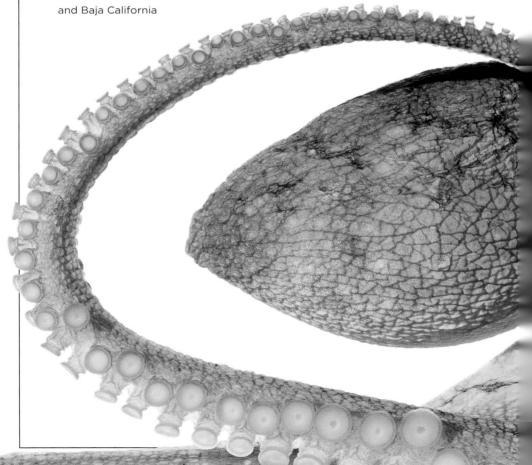

he California two-spot octopus's most striking feature—the iridescent blue rings with a chain-link pattern on the sides of its head—create an illusion that draws the attention of would-be predators away from the creature's vulnerable true eyes. The dazzling blue circles, called ocelli, mesmerize the beholder like precious gems, buying the octopus time to escape or assume a color-changing disguise to blend in with its surroundings.

Female California two-spots endure dramatic and difficult pregnancies. Females lay up to 800 eggs at a time, and once the hatchlings emerge, the mother enters what researchers have described as a death spiral.

As the California two-spot infants begin their lives on the ocean bottom, the mother might begin to twist her arms together or mutilate herself. Researchers have even observed the females eating the tips of their own arms during this grim post-birth period. While cannibalism is not uncommon among octopus species, self-cannibalism is considered unusual.

Chemical analysis of the female two-spots who underwent these changes showed that they release—among other things—a cholesterol precursor called 7-dehydrocholesterol (7-DHC) from their optic gland. In humans, elevated levels of 7-DHC can lead to a rare disease, Smith-Lemli-Opitz syndrome, with symptoms that include self-injury. Researchers surmise the chemical might have a similar effect on California two-spot octopus mothers.

# Dumbo Octopus

## *Grimpoteuthis* spp.

**LIFE SPAN:** 3–5 years

**SIZE:** 8–12 inches (20–30 cm)

**WEIGHT:** Unknown

**RANGE:** Tropical and subtropical Atlantic Ocean

**DIET:** Worms, bivalves, copepods, isopods, amphipods

**SIZE RELATIVE TO A HUMAN HAND:**

Among all octopuses, the dumbo octopus occupies the deepest part of the ocean: the lower bathyal and abyssal zones, down as far as some 16,400 feet (5,000 m) deep. Its earlike fins evoke the beloved flying elephant—and, like its namesake, it uses its "ears" for motion, propelling itself through the water with the elephantine flaps that protrude from its mantle.

In the pitch-black world where the dumbo octopus resides, the pressure is immense—about 600 atmospheres or 8,820 pounds per square inch (60,810 kPa) at the lowest depths of the abyssal zone—and life-forms are sparse. Its bell-shaped, semigelatinous body allows for efficient movement and navigation through the dark depths, while the umbrella-like webbing between its arms aids in locomotion and capturing prey. A small internal U-shaped shell within its mantle supports the muscular fins on its head, enhancing its swimming capabilities.

The dumbo octopus has only a single row of suckers on its arms, but alongside this row are a set of finger-like appendages, called cirri, offering additional dexterity. With its cirri, the dumbo octopus can handle small prey and create water currents to guide food toward its mouth. The cirri are equipped with chemoreceptors, enabling the octopus to detect chemical cues crucial for tracking down prey in the dark.

Male dumbos transfer their sperm to females in an unconventional way. Unlike many of its relatives, the male of this species lacks a hectocotylus, or specialized reproductive arm. Instead, it uses its large suckers to

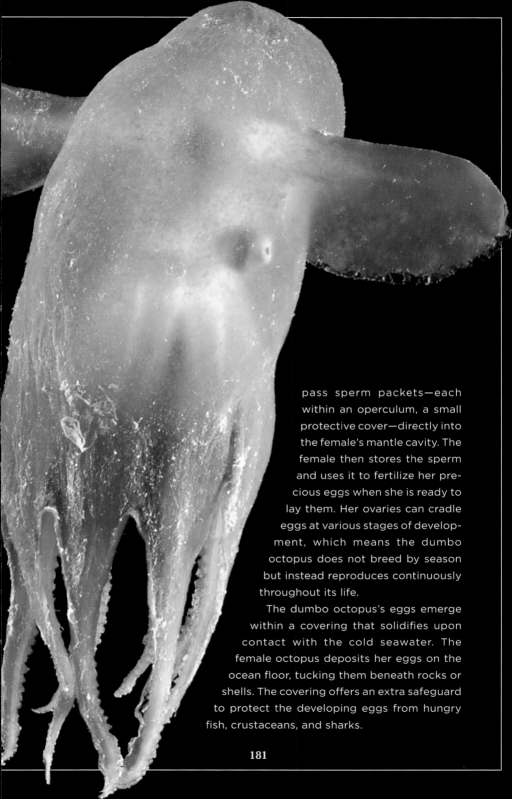

pass sperm packets—each within an operculum, a small protective cover—directly into the female's mantle cavity. The female then stores the sperm and uses it to fertilize her precious eggs when she is ready to lay them. Her ovaries can cradle eggs at various stages of development, which means the dumbo octopus does not breed by season but instead reproduces continuously throughout its life.

The dumbo octopus's eggs emerge within a covering that solidifies upon contact with the cold seawater. The female octopus deposits her eggs on the ocean floor, tucking them beneath rocks or shells. The covering offers an extra safeguard to protect the developing eggs from hungry fish, crustaceans, and sharks.

# Mimic Octopus

## *Thaumoctopus mimicus*

**LIFE SPAN:** 1–2 years

**SIZE:** 19 inches (48 cm)

**WEIGHT:** Unknown

**RANGE:** Tropical southwestern Pacific Ocean, including the Red Sea

**DIET:** Worms, echinoderms, crustaceans, fish

**SIZE RELATIVE TO A HUMAN HAND:**

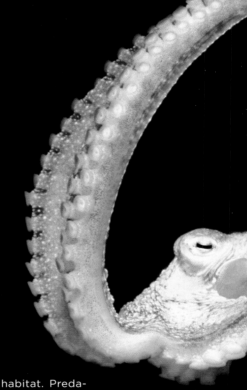

The nomadic mimic octopus thrives in shallow coastal waters, inhabiting soft sediment environments such as silt or sand. Adapted to these unique surroundings, the octopus either creates a burrow using its long, dexterous arms to manipulate the sand or else invades existing burrows made by animals such as crabs, fish, or worms. These temporary homes offer shelter for the mimic octopus as it embarks on its daily tasks of foraging and exploration.

The mimic octopus goes on multiple hunting trips each day, seeking a delectable smorgasbord made up of the worms, echinoderms, crustaceans, and fish that share its shallow seabed habitat. Predators might hover nearby, but the mimic octopus employs its unique shape-shifting abilities to baffle its enemies.

The mimic octopus has the reputation of imitating the shape and swimming motions of at least 15 different sea creatures, including flatfish and sand anemones. It might squeeze itself

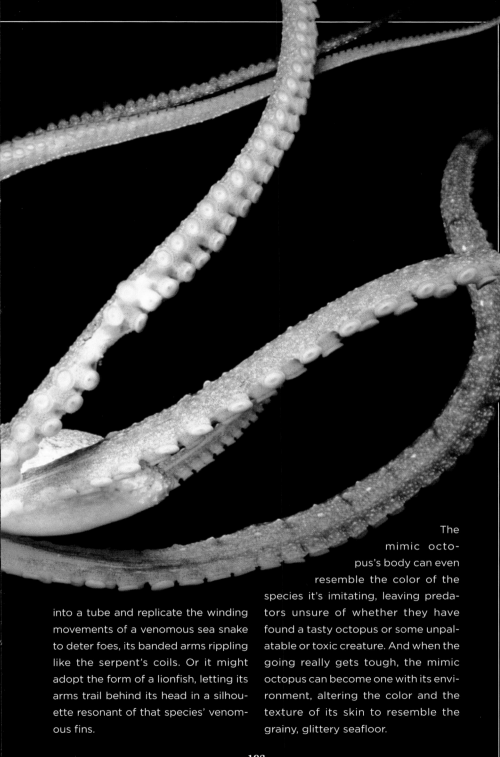

into a tube and replicate the winding movements of a venomous sea snake to deter foes, its banded arms rippling like the serpent's coils. Or it might adopt the form of a lionfish, letting its arms trail behind its head in a silhouette resonant of that species' venomous fins.

The mimic octopus's body can even resemble the color of the species it's imitating, leaving predators unsure of whether they have found a tasty octopus or some unpalatable or toxic creature. And when the going really gets tough, the mimic octopus can become one with its environment, altering the color and the texture of its skin to resemble the grainy, glittery seafloor.

# Acknowledgments

Working on this book has been a joy. I'm grateful to all the scientists, divers, filmmakers, and aquarium keepers quoted in this book. I have learned so much from them all. I'm especially indebted to those who took time out to talk with me—some multiple times—and who graciously read the manuscript in its various iterations to make sure I represented their fascinating work accurately.

I am honored that this book begins with the splendid foreword written by wildlife scientist Alex Schnell and that its pages include the fabulous species profiles by my friend, the founder of OctoNation, Warren Carlyle. I love that our names are together in this book.

I'm also delighted to acknowledge my colleagues at National Geographic and SeaLight Pictures. Without exception, everyone I've dealt with at both organizations has been not only brilliant but also overwhelmingly helpful and encouraging. Thank you for making this gorgeous book—and also for creating a glorious film series.

I thank my wonderful literary agents, Molly Friedrich and Heather Carr, who generously connected me with National Geographic for this project. I thank my husband, the writer Howard Mansfield. (If I had three hearts, they'd all belong to you!)

And finally, I want to thank all the octopuses, both wild and in captivity, whom I have been privileged to meet since I met my first, Athena, in 2011. This book is written in their honor, in hopes that spreading the word about these surprisingly smart and sensitive animals inspires us to improve welfare for octopuses—and all creatures, everywhere.

# Illustrations Credits

Cover and back cover, David Liittschwager/National Geographic Image Collection; 2-3, Laurent Ballesta, Gombessa Expeditions, Andromède Océanologie; 4, Alex Mustard/NPL/Minden Pictures; 6-7, Gabriel Barathieu/Biosphoto/Minden Pictures; 8-9, Enric Sala/National Geographic Image Collection; 10, Alex Mustard/Nature Picture Library; 16-7, Steven Kovacs/Biosphoto/Minden Pictures; 18, Katherine Lu; 23, David Fleetham/Nature Picture Library; 26-7, Alex Mustard/Nature Picture Library; 28, Gary Bell/Oceanwide Images; 31, Magnus Lundgren/NPL/Minden Pictures; 34-5, Solvin Zankl/Nature Picture Library; 38, Ellen Muller; 40-1, David Hall/Nature Picture Library; 42, Andre Johnson; 44 and 45, David Liittschwager/National Geographic Image Collection; 48, Alex Mustard/Nature Picture Library; 52-3, Paulo de Oliveira/Biosphoto; 57, David Fleetham/Stocktrek Images/Biosphoto; 60-1, Gabriel Barathieu/Biosphoto/Minden Pictures; 63, William Gladstone; 66-7, Ernie Black - @ernieblackphoto; 72, Sergio Hanquet/Biosphoto/Alamy Stock Photo; 74-5, Hidde Juijn @octoparazzo; 76, Gabriel Barathieu/Biosphoto/Minden Pictures; 81, SeaTops/Alamy Stock Photo; 84-5, Richard Herrmann/Minden Pictures; 89, GBH Archives; 93, WaterFrame/Alamy Stock Photo; 96-7, David Scheel; 100, Douglas Seifert; 104-5, Andrey Nekrasov/Alamy Stock Photo; 108-9, Franco Banfi/Biosphoto; 110, David Fleetham/Alamy Stock Photo; 115, David Liittschwager/National Geographic Image Collection; 118-9, Fred Bavendam/Nature Picture Library; 123, Ellen Muller; 124, David Scheel; 128-9, Greg Lecoeur; 131, Michael Amor/Alamy Stock Photo; 134-5, Justin Gilligan; 138, Franco Banfi/WaterFrame - Agence/Biosphoto; 140-1, Kaspa Blewett/snorkeldownunder; 142, Douglas Seifert; 146, Magnus Lundgren/Nature Picture Library; 152-7, David Liittschwager/National Geographic Image Collection; 158-9, Constantinos Petrinos/NPL/Minden Pictures; 160-1, Joel Sartore/National Geographic Photo Ark, photographed at the Alaska SeaLife Center; 162-5, David Liittschwager/National Geographic Image Collection; 166-7, Magnus Lundgren/NPL/Minden Pictures; 168-9, Joel Sartore/National Geographic Photo Ark, photographed at the Dallas World Aquarium; 170-1, David Liittschwager/National Geographic Image Collection; 172-3, Magnus Lundgren/Nature Picture Library; 174-5, Fred Bavendam/Nature Picture Library; 176-7, Joel Sartore/National Geographic Photo Ark, photographed at Riverbanks Zoo and Garden; 178-9, David Liittschwager/National Geographic Image Collection; 180-1, David Shale/Nature Picture Library; 182-3, Jeff Rotman/Nature Picture Library; 190 (UP), David Scheel; 190 (CTR), Annette Matthews Photography - Dallas, TX; 190 (LO), Harriet Spark.

# Index

# About the Authors

SY MONTGOMERY is a naturalist and author of more than 30 books of nonfiction for adults and children, including the National Book Award finalist *The Soul of an Octopus* and the recent *Of Time and Turtles.* Her adventures have introduced her to silverback gorillas in Zaire, vampire bats in Costa Rica, dolphins in the Amazon, and tree kangaroos in Papua New Guinea. She lives with her husband—the writer Howard Mansfield—and border collie, Thurber, in New Hampshire.

WARREN K. CARLYLE IV is the founder and CEO of Octo-Nation, a nonprofit organization that is home to more than one million members and that works to inspire wonder of the ocean by educating the world about octopuses. His work in community building has been featured by the Explorers Club, Upworthy, and South by Southwest. He lives in Austin, Texas.

ALEX SCHNELL, PH.D., is a National Geographic Explorer, recipient of the National Geographic Society's 2023 Wayfinder Award, and presenter for National Geographic's blue-chip television series *Secrets of the Octopus.* She researches cephalopods, including octopuses and cuttlefish, as a wildlife scientist and research associate at the University of Cambridge's Comparative Cognition Lab. She lives in Lake Macquarie, Australia.

Since 1888, the National Geographic Society has funded more than 14,000 research, conservation, education, and storytelling projects around the world. National Geographic Partners distributes a portion of the funds it receives from your purchase to National Geographic Society to support programs including the conservation of animals and their habitats.

National Geographic Partners, LLC
1145 17th Street NW
Washington, DC 20036-4688 USA

Get closer to National Geographic Explorers and photographers, and connect with our global community. Join us today at nationalgeographic.org/joinus

For rights or permissions inquiries, please contact National Geographic Books Subsidiary Rights: bookrights@natgeo.com

Library of Congress Cataloging-in-Publication Data
Names: Montgomery, Sy, author.
Title: Secrets of the octopus / Sy Montgomery.
Description: Washington, D.C. : National Geographic, [2024] | Includes
    index. | Summary: "This book reveals new science and remarkable
    discoveries about the octopus, one of nature's most elusive and
    intelligent animals"-- Provided by publisher.
Identifiers: LCCN 2023023456 | ISBN 9781426223723 (hardcover)
Subjects: LCSH: Octopuses.
Classification: LCC QL430.3.O2 M657 2024 | DDC 594/.56--dc23/eng/20230613
LC record available at https://lccn.loc.gov/2023023456

ISBN: 978-1-4262-2372-3

Printed in the United States of America

24/WOR/3